IMAGES
of America

CATHOLICS OF
SAN FRANCISCO

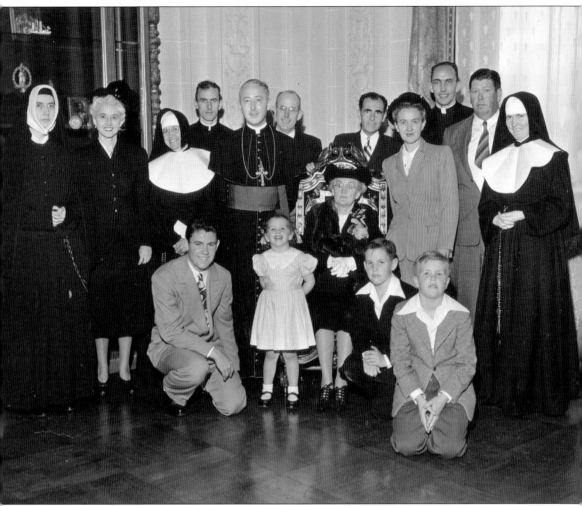

Hugh A. Donohoe is pictured with the Donohoe family on October 7, 1947, the day he was ordained auxiliary bishop for the Archdiocese of San Francisco. He later was appointed bishop of Stockton. Two of his brothers became Jesuits. Two sisters joined the Notre Dame order, and his surviving sister, Helen (far left), is a Religious of the Sacred Heart. Sister Helen was unable to attend the ordination because she was cloistered, so the family brought the party to her at the Convent of the Sacred Heart. (Courtesy of the Archives for the Archdiocese of San Francisco.)

ON THE COVER: An annual event at parochial schools, such as St. Gabriel in San Francisco, was the May Procession in honor of the Blessed Mother. Children walked around the school yard in solemn order singing such songs as "Immaculate Mary." At the end, a student was designated to place a crown of flowers on the head of a statue of Mary, a singular honor. (Courtesy of St. Gabriel School.)

IMAGES
of America

CATHOLICS OF
SAN FRANCISCO

Rayna Garibaldi and
Bernadette C. Hooper

ARCADIA
PUBLISHING

Published by Arcadia Publishing
Charleston SC, Chicago IL, Portsmouth NH, San Francisco CA

Printed in the United States of America

Library of Congress Catalog Card Number: 2008922712

For all general information contact Arcadia Publishing at:
Telephone 843-853-2070
Fax 843-853-0044
E-mail sales@arcadiapublishing.com
For customer service and orders:
Toll-Free 1-888-313-2665

Visit us on the Internet at www.arcadiapublishing.com

CONTENTS

ACKNOWLEDGMENTS

We gratefully acknowledge all those who kindly opened their homes, archives, schools, convents, rectories, and parish offices for our search for stories and images. A special thanks to Dr. Jeffrey M. Burns for his constant, gracious help and to Frank Dunnigan, Fr. Daniel Maguire, Andrea Miller, Fr. John K. Ring, and Paul Totah for their interest and assistance.

We would also like to thank the following individuals: Bertha Acuna; Jean Alexander; Mary Ashe; Katherine Atkinson; Theresa Avansino; Stella Bialous; the Bisazza family; Sr. Pauline Borghello, R.S.M.; Fr. William Brady; Miles Butcher; Andrew Canepa; Laurie Anne Carey; Maureen Castro; Leo Catahan; Patricia Cavagnaro; Sr. Judy Carle, R.S.M.; Sally Cowan; Nancy Hayden Crowley; Julia De La Torre; Christine Doan; Sr. Helen Donohoe, RSCJ; Marie Driscoll; Eugene and Georgiana Egbert; Joe Elsbernd; Danielle Elu; Edie Epps; Barbara Fenech; the Fiasconaro family; Olivia Fisher; Beverly Ganzert; the Garibaldi family; Fr. Paul Gawlowski; O.F.M. Conv.; Mary Geracimos; Maria Gonzalez; Terry Hanley; Marie Schnell Harrington; Mary Ellen Hoffman; the Hooper family; Annely Kelleher; Mary Kellogg; Sheila O'Day Kiernan; Paula Knutsen; Msgr. Labib Kobti; Sr. Adele Marie Korhummel, C.S.J.; Sr. Jane De Lisle, C.S.J.; Aurelia Lynch; Sr. Patrick Mary, O.P.; Audrey Magnusen; JoAnn Masino-Lara; Suzanne McCarthy; David R. Mehrwein; Eileen Mize; Sr. Carolyn Marie Monahan, O.P.; Virginia Murillo; Gertrude Nebeling; Claire O'Sullivan; Patricia Pinnick; Beverly Bermingham Powelson; Jim Reinhardt; Sr. Jude Ristey, P.B.V.M.; Msgr. Jose Rodriquez; Joey Rosel; Karen Saeger; Maria Julia Samone; JoAnn Shain; Etienne Simon; Christine Stinson; Tanya Spishak; Fr. Charito Suan; Kathy Symkowick; Fr. John Talesfore; Shirley Terry; Maria Vickroy-Peralta; St. Mary Susanna Vasquez, O.P.; Paul Warren; Monica Williams; Jim Woods; Josephine Zaragoza; and Paula Zimmermann. We would also like to thank our editor, John Poultney, for his amazing energy. Most especially, we are thankful for the examples of faith shared by our family members.

INTRODUCTION

Catholics of San Francisco tells the story of the faithful in this city named for a beloved saint. Catholicism was the first nonnative tradition in California and the most influential. From the start, Catholic missionaries, soldiers, and settlers from many nations put their mark on the history, traditions, and outlook of San Francisco through their institutions—churches, schools, hospitals, and charities. In San Francisco, Catholics have been leaders from the parish level to city hall and beyond to the state level. At large, they thought of themselves as San Franciscans. Along with other denominations, the faithful have worked to improve community life. Catholicism has had a great influence on San Francisco's history and development.

The history of Catholicism in San Francisco had its origin in the mission system that brought Christianity to the native people of California. The first Mass at Mission San Francisco de Asis was celebrated on June 29, 1776, by Fr. Francisco Palou, a Franciscan missionary. Life in the missions was not an idyllic existence for natives or missionaries. While many natives embraced the new religion, there were large numbers who hesitated to discard their traditional ways. Many natives died from diseases for which they had no natural immunities. Throughout the early years, they labored to establish a self-sufficient settlement in the style taught by the Franciscan friars. The work of the Ohlones in the development of Mission Dolores came full circle with the appointment of Andrew Galvan as curator. Galvan is descended from two individuals who worshiped at Mission Dolores in the early days: Faustino, a Saklan/Bay Miwok, baptized on November 1, 1797, and Liberato, a Jalquin Ohlone/Bay Miwok baptized on November 18, 1801.

With Mexico's independence from Spain in 1821, the funding for all California missions decreased to the point that they became less like regional centers and began to function like parishes. After the discovery of gold at Sutter's Mill in 1848, San Francisco experienced its most significant increase in population. Life in the Gold Rush city was unruly at times, and its population was in desperate need of a religious presence and supporting institutions such as churches, schools, hospitals, and orphanages.

In response to this situation, the Vatican established the Archdiocese of San Francisco in 1853. Joseph Sadoc Alemany, a Spanish Dominican, was chosen to become San Francisco's first archbishop. Alemany was a naturalized U.S. citizen and had been a missionary in Kentucky, Ohio, and Tennessee. He was multilingual, an invaluable skill for this multicultural city. In establishing a system of parishes, schools, and hospitals, Alemany called upon religious orders from many countries to build and staff these institutions. Some of the first groups to make the long journey to San Francisco were the Presentation Sisters, the Dominican Sisters, the Sisters of Notre Dame de Namur, the Daughters of Charity, the Sisters of Mercy, and the Jesuit Fathers. Due to the cosmopolitan nature of the city, it was not unusual for people to be served by religious orders of a different country of origin than their own. For example, St. Ignatius College was founded by Italian Jesuits whose first students were mostly Irish Catholics.

After Archbishop Alemany retired in 1884, his successor, Patrick W. Riordan, undertook the restoration of many original church buildings, both wooden and stone, along with an

expansion of the parochial school system. Riordan was known as an impressive fund-raiser, and the faithful responded generously. He accomplished something that had eluded even Alemany—the establishment of an archdiocesan seminary, St. Patrick's, in Menlo Park. During Riordan's time, the city also experienced the earthquake and fire of 1906, which ravaged much of the infrastructure of the archdiocese as well as the buildings belonging to many individual religious orders.

Edward J. Hanna succeeded Archbishop Riordan in 1915, serving in the post until 1935. San Francisco had been almost entirely rebuilt after the losses of 1906, and Hanna, along with Catholic San Franciscans, participated in the growth of this financial and cultural center of the West Coast. Hanna led by example and was often called upon to mediate worker disputes, in addition to another well-known Catholic cleric of the day, Fr. Peter Yorke. As one of the city's earliest advocates for youth, Fr. Oreste Trincheri, S.D.B., of SS. Peter and Paul's organized the Salesian Boy's Club in 1918 to give the neighborhood youth a wholesome place to gather and socialize.

Hanna's successor was John J. Mitty, a former chaplain of West Point who was known for his stern but compassionate leadership. During his quarter-century tenure, more than 800 men were ordained to the priesthood, six of whom became bishops, including Hugh Donohoe and Merlin Guilfoyle. When Mitty died in 1961, parochial schoolchildren lined the route of his funeral procession to Holy Cross Cemetery.

Joseph T. McGucken was ordained as San Francisco's fifth archbishop on April 13, 1962, becoming the first native Californian to hold this post. He undertook the financing and building of a new St. Mary's Cathedral after fire had destroyed the cathedral on Van Ness Avenue six months into his time in office. Various administrative changes were made under his leadership, and the archdiocese currently includes the counties of San Francisco, Marin, and San Mateo. Catholics comprise 425,000 out of a total of population of 1.7 million in these counties.

During the 1980s, San Francisco confronted the AIDS epidemic. The faithful also found themselves challenged by the issue of abortion. On October 17, 1989, the city was struck by a large earthquake, causing serious damage to eight churches. Archbishop John R. Quinn, the sixth archbishop, became an outspoken advocate for refugees as well as a critic of the arms race.

Archbishop Quinn was succeeded by William J. Levada, who had to address two major issues, the closure of several well-loved parishes and the emergence of a decades-old sexual abuse scandal involving some clergy. Parishioners of the closed parishes were warmly welcomed into nearby parishes, helping to soften this difficult transition. The revelations of the abuse scandal shocked and tested the patience of the faithful. Now a cardinal, Levada is the prefect of the Congregation for the Doctrine of the Faith at the Vatican.

Catholic life in San Francisco today remains a story of newcomers from other parts of the United States as well as the four corners of the world, so it is fitting that the current archbishop, George H. Niederauer, is also a newcomer to the region, having previously served as Bishop of Salt Lake City. He has also been a seminary professor and is a scholar.

The largest immigrant groups to make San Francisco their home are the Irish, Italian, and Hispanic. There are also Catholic French, German, Chinese, Filipino, Samoan, Japanese, Burmese, Maltese, Croatian, Slovenian, Polish, Arab, Korean, and Portuguese communities. Successive generations have contributed diverse devotions and festivals to the city's religious and cultural life. There are special devotions to Our Lady of Guadalupe, the Madonna del Lume, Santo Nino de Cebu, the Blessing of the Fishing Fleet, and observations including the Columbus and St. Patrick's Day parades. In the history of the city, Catholic events have drawn thousands: the annual Novena to St. Anne Church, the Holy Name parade of 1924 that included 80,000 marchers, the 1961 Rosary Crusade at the Polo Field in Golden Gate Park that drew 500,000 of the devout, plus massive crowds for the 1987 visit of Pope John Paul II.

San Francisco parochial schools reached their highest enrollment numbers in the early 1960s, at which time many Catholics were making the move to the suburbs, changing the demographics of the parishes and the schools. The role of the lay teacher, offsetting a decline in the numbers

of nuns, was essential to the survival of the parochial school system. Some city parishes and schools never regained their prior levels of enrollment, and by the year 2000, many parishes and schools had been closed. In the 1950s, there were 13 Catholic girls' high schools in San Francisco; in 1990, that number had fallen to three. Sacred Heart High School and Cathedral High School became Sacred Heart Cathedral Preparatory, and St. Ignatius College Preparatory went coeducational in 1989. In 2000, Stuart Hall High School, an all-boys school, opened, joining Riordan High School as the only two all-boys schools, reaffirming both the need and the interest for single-sex education as an option.

Many parishes had particular devotions. An octogenarian recalls that when she was a student at St. Dominic's, she was a member of the Handmaids of the Blessed Sacrament. On the third Sunday of the month, there was a Rosary and procession around the St. Dominic's block (Steiner, Pine, Pierce, and Bush Streets), led by the Handmaids wearing veils, white middy blouses, and white skirts. Although no photographs of the processions could be found, the event is well-remembered by a generation.

It is not unusual for local Catholics to stay in the same parish for most of their lives, marking the passage of years with family and neighbors' religious events—from baptisms to funerals. It was common knowledge which parishes had the best festivals, luncheons, bingo nights, dances, teen and young adult clubs, and the location of the latest-scheduled Sunday mass each week. Parishes had their own personality, mostly determined by the outlook of their pastor. There has been a history of good-natured rivalries between parishes. In the 1950s and 1960s, for example, the pastors of St. Cecilia's and Holy Name used to vie for the number of newly ordained priests from each location. Various rivalries between the sports teams of numerous schools begin as early as grade school and are remembered throughout life. Fund-raising duties for building, maintaining, and improving churches and schools have fallen to the pastors with the generous help offered by numerous mothers' clubs and men's groups.

There are the traditions that perhaps only Catholics could understand. Fifty years ago, children at St. Brendan's School were encouraged to dress as their favorite saint for Halloween. One can only imagine a small St. Patrick with bishop's miter and croft or a seven-year-old would-be nun. For children to understand the importance of the work of missions in underdeveloped countries, special collections were taken at Catholic elementary schools for decades. When a class collected $5, they received a certificate and the right to list a name of their choice for their "Pagan Baby." At St. James Girls School in 1964, Sr. M. Claudia, O.P., was pleased to write John, Paul, and George on certificates but drew the line at Ringo. In the time of abstinence from meat on Fridays, pre-1966, dispensations were routinely proclaimed so the faithful could enjoy a St. Patrick's Day meal of corned beef and cabbage or a post-Thanksgiving turkey sandwich in good conscience.

Catholic high school students have long been involved in a variety of extracurricular events such as the Summer School of Catholic Action and the annual Catholic High School Federation meetings. A graduate of Mercy High's first class recalls attending a lecture on *Brown v. Board of Education* at the Summer School of Catholic Action at the time the case was being heard by the Supreme Court. Sodality groups have long engaged in public service volunteerism to groups assisting the elderly, handicapped, and at-risk youth.

Among Catholic organizations, the Knights of Columbus, the Legion of Mary, the Order of Malta, the Italian Catholic Federation, and the St. Anthony Foundation all play an important part in offering programs and assistance to the people of San Francisco.

Catholic life does not stop with death. The first nonnative settlers were buried at Mission Dolores cemetery along with thousands of the Ohlones. Calvary Cemetery was established in the post–Gold Rush era and was closed in 1939. Holy Cross Cemetery and the Italian Cemetery are popular final resting places for local Catholics. In light of recent ecclesiastical changes, both are now accommodating the cremains of the departed.

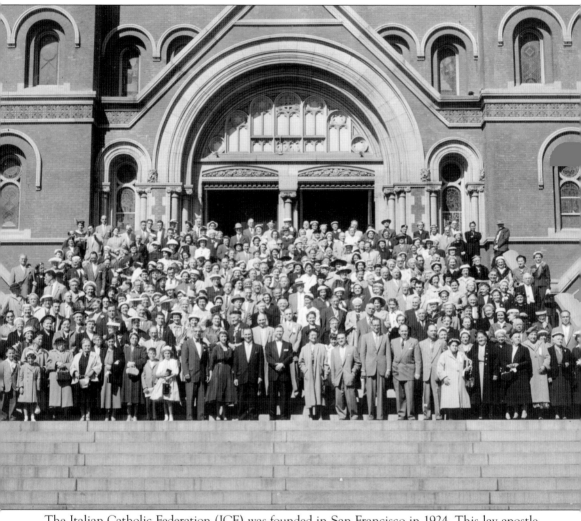

The Italian Catholic Federation (ICF) was founded in San Francisco in 1924. This lay apostle organization is dedicated to charitable works. Its spiritual home is the Immaculate Conception Church in the Mission District. This photograph commemorates the annual Mass held on May 10, 1957, at St. Mary's Cathedral on Van Ness Avenue. (Courtesy of the Archives for the Archdiocese of San Francisco.)

One

FAITH

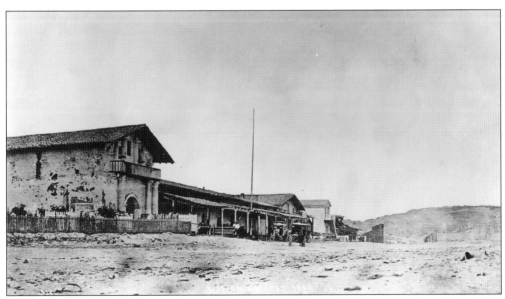

Mission San Francisco de Asis, commonly known as Mission Dolores, was founded in 1776. This building was constructed by the Ohlones and dates to 1791. For many years after the secularization of the mission lands by the Mexican government, this was a sleepy settlement. All that changed with the Gold Rush. (Courtesy of the San Francisco History Center, San Francisco Public Library.)

Maria de la Concepcion Marcela Arguello and Nikolai Rezanov, a Russian explorer, met and fell in love when he came to San Francisco aboard a Russian ship in search of supplies. He died on the return trip to Russia to obtain the tsar's permission for the marriage. Concepcion chose a religious life as Sr. Mary Dominca, O.P.. She is buried at the Dominican Cemetery in Benicia. (Courtesy of the San Francisco History Center, San Francisco Public Library.)

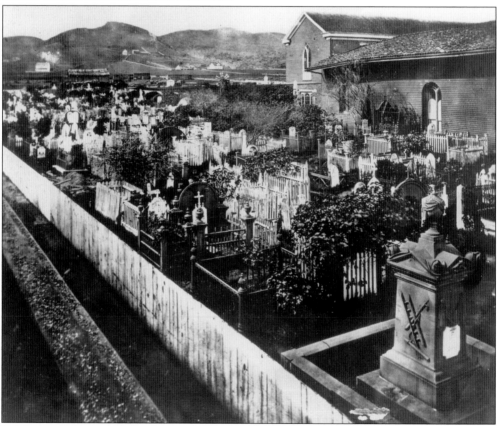

In Mission Dolores Cemetery are buried hundreds of early Catholic settlers from throughout the world and thousands of Ohlones. (Courtesy of the San Francisco History Center, San Francisco Public Library.)

Joseph Sadoc Alemany, O.P., was appointed as San Francisco's first archbishop on July 29, 1853. A naturalized citizen, he was also multilingual and tireless in his efforts to build the churches and schools that would be needed for Catholics in the West. To that end, he brought members of many religious orders to San Francisco. (Courtesy of a private collector.)

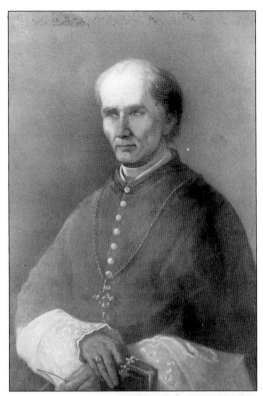

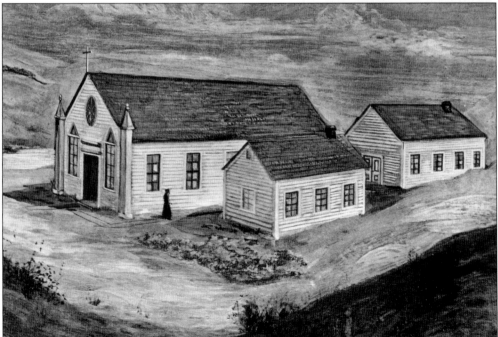

The original St. Ignatius Church and College were located in sand dunes on Market Street between Fourth and Fifth Streets. Building materials were scarce, so it is not surprising that their buildings were small. (Courtesy of the Archives for the Archdiocese of San Francisco.)

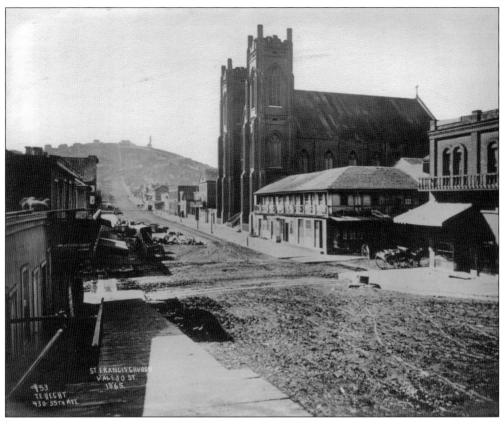

St. Francis of Assisi Church, the first Catholic parish church in the area after Mission Dolores, was constructed in 1851 on Vallejo Street. This is how it appears in the neighborhood in 1865 with Russian Hill its right. It is in the area city residents have long called North Beach. (Courtesy of the Archives for the Archdiocese of San Francisco.)

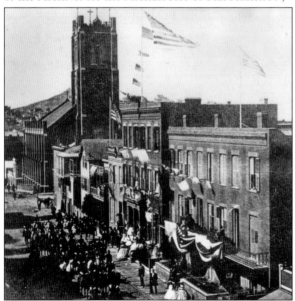

The first Cathedral of St. Mary of the Assumption on California Street at Dupont Avenue (now Grant Avenue) dominates the neighborhood during this 1862 parade. The neighborhood became very rough in the decades that followed. Archbishop Joseph Sadoc Alemany, O.P., stayed on but made plans for a bigger cathedral on Van Ness Avenue. (Courtesy of the Archives for the Archdiocese of San Francisco.)

John Sullivan traveled to California at the age of 18 with his orphaned siblings in the famous Stephens Townsend Murphy wagon train party of 1844. He prospered and married the orphaned Catherine Farrelly. Together they donated the land for the first cathedral in California, St. Mary of the Assumption on California Street. Catherine Sullivan is buried in the crypt at what is now called Old St. Mary's. (Courtesy of Sheila O'Day Kiernan.)

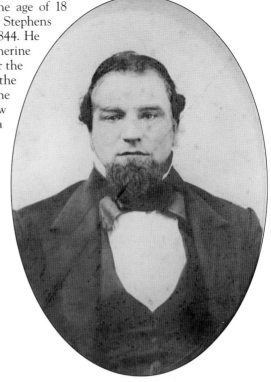

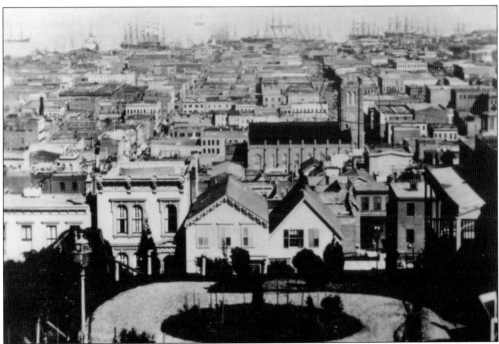

This photograph from the hill above Old St. Mary's Cathedral in 1855 shows the harbor in the middle ground and the waterline. This was the same year the cathedral bell was hung and used for the first time. (Courtesy of the Archives for the Archdiocese of San Francisco.)

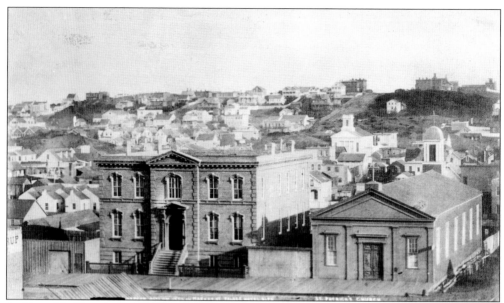

St. Patrick's Church (right) and the Catholic Orphan Asylum on Market Street (later the site of the Palace Hotel) was constructed in 1856. The original building still exists. It is the oldest wooden structure in San Francisco. For years, it was the parish hall for Holy Cross Church on Eddy Street near Divisadero Street. Now it is the monastery for a Tibetan Buddhist Temple. (Courtesy of the Archives for the Archdiocese of San Francisco.)

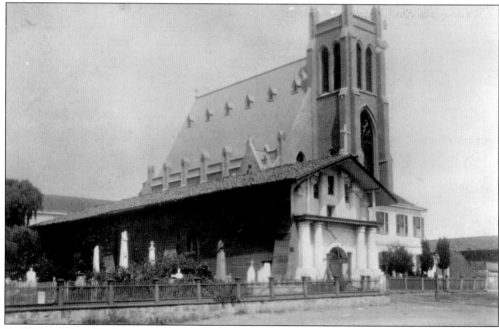

In 1876, one hundred years after the founding of the mission settlement at the Dolores Lagoon, a parish church was constructed to accommodate the large number of Catholics in the neighborhood. The parish church was destroyed by the earthquake and fire 30 years later. It is said that parishioners of long standing have the option of marrying at the old mission. (Courtesy of the Archives for the Archdiocese of San Francisco.)

The Paulist Priests came to San Francisco and set up regional headquarters at St. Mary's for their missions and retreats. The Paulists assumed responsibility for the parish in 1894. They established many programs to serve the neighborhood, including the Catholic Chinese Mission with programs that included language lessons, adult conversion, and education. (Courtesy of the Archives for the Archdiocese of San Francisco.)

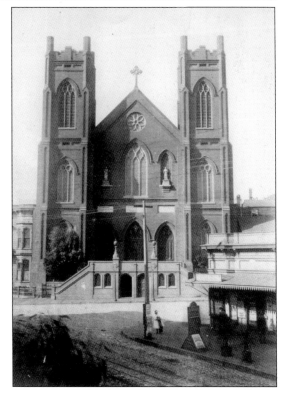

St. Francis of Assisi Church was founded in 1849 in North Beach, and the present church was constructed in 1860. Since 1999, it has been the National Shrine of St. Francis of Assisi, offering devotions of the Rosary, the Angelus, and the Chaplet of the Divine Mercy six days a week. (Courtesy of the Archives for the Archdiocese of San Francisco.)

Twins James and Sylvester McKenna grew up in St. James parish. Since they were identical, their mother often could not tell them apart. Jim served in World War I and was active in the American Legion. He is buried at the Presidio Cemetery beside his wife and youngest son. Sylvester found his career in the service. He died in World War II when the ammunitions ship he served on was blown up. (Courtesy of Mary McFadden.)

Thomas Francis Doyle was a builder who constructed many homes in San Francisco and the hospital at Hospital Cove, Angel Island. He and his wife, the former Matilda O'Shea, raised their family on Harrison Street in St. Peter's parish. (Courtesy of the Doyle family.)

Native San Franciscans Margaret Rose Broderick and John Joseph Kane married on April 29, 1902, at St. Patrick's Church. It was a double wedding. The other bride was Julia, Margaret's older sister, and Julia's groom was Albert S. Owen. The Kanes settled in Most Holy Redeemer parish. (Courtesy of the Knutsen family.)

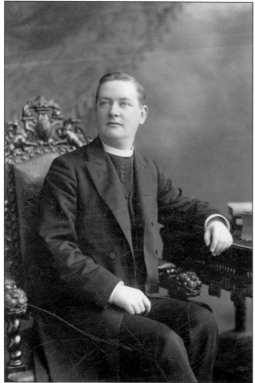

Fr. Peter C. Yorke, native of Galway, is one of the best known priests to have served in San Francisco. Yorke was pastor of St. Peter's parish, editor of the *Monitor* (the archdiocesan newspaper), and a champion of the rights of the laborer. In the 1890s, when this photograph was taken, Father Yorke was confronting the anti-Catholic group, the American Protective Association, in speech and print. (Courtesy of the Archives for the Archdiocese of San Francisco.)

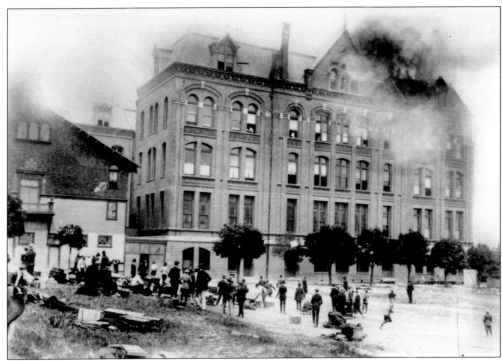

Fire consumed the fourth floor of St. Patrick Seminary shortly after the 1906 earthquake. When the seminary was repaired, it no longer included a fourth floor. (Courtesy of the Archives for the Archdiocese of San Francisco.)

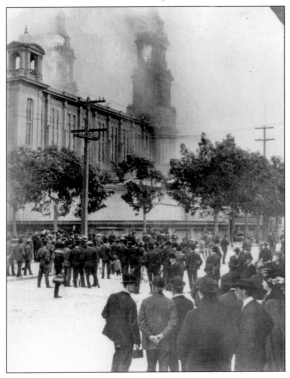

St. Ignatius (SI) Church and College at Hayes Street and Van Ness Avenue burnt on April 18, 1906, in the aftermath of the earthquake. The last act of SI president Fr. John Frieden, S.J., on the campus was to remove the Eucharist from the Tabernacle and place it in its ciborium. Then he led a small procession uphill to the Holy Family Convent at Hayes and Fillmore Streets. Many who saw Father Frieden and understood what he was carrying bowed their heads or genuflected. (Courtesy of St. Ignatius, the University of San Francisco, and the California Province of the Society of Jesus.)

St. Boniface Church on Golden Gate Avenue was shaken by the 1906 earthquake and gutted by the following fire. (Courtesy of the Archives for the Archdiocese of San Francisco.)

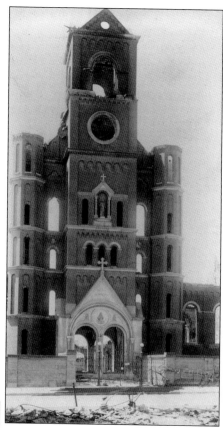

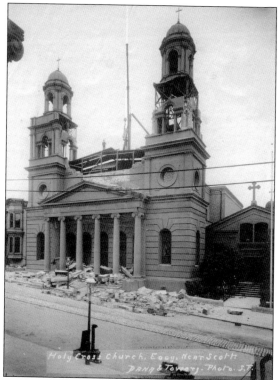

The earthquake and fire of 1906 devastated much of San Francisco. This photograph taken after the disaster shows the damage to Holy Cross Church at Eddy and Divisadero Streets. The church building now serves a Tibetan Buddhist community as a temple. (Courtesy of the Archives for the Archdiocese of San Francisco.)

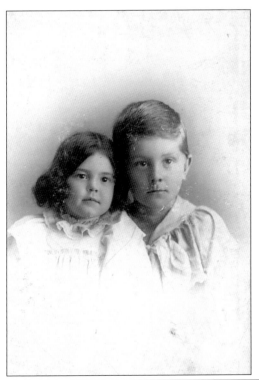

Artemise and Francis LaTulipe of Alabama Street were born to French Canadian parents and baptized at Notre Dame des Victoires Church. Artemise grew up to marry and have a family. She lived into her 90s in St. Philip's parish. Frank was a driver for Mayor James "Sunny Jim" Rolph. Encouraged by Rolph, Frank continued his education and became the first criminologist of the City and County of San Francisco. (Courtesy of Mary McFadden.)

The original St. Agnes Church was built in 1893. In the background of this photograph is the panhandle of Golden Gate Park. (Courtesy of the Archives for the Archdiocese of San Francisco.)

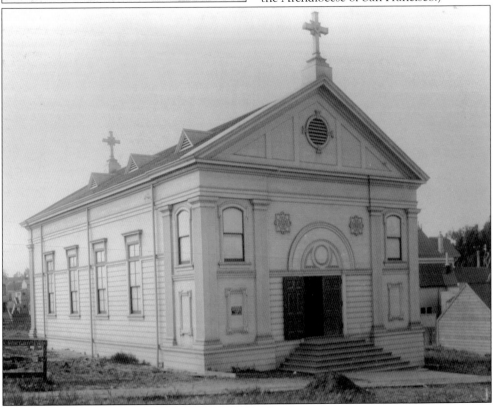

A studio portrait was reserved for special occasions. This First Holy Communion photograph of Clara Muzio was taken on May 29, 1910. (Courtesy of the Fiasconaro family.)

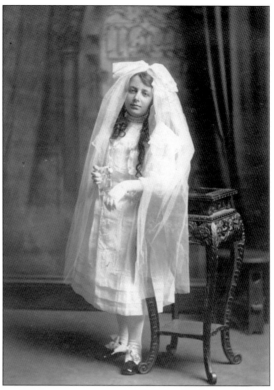

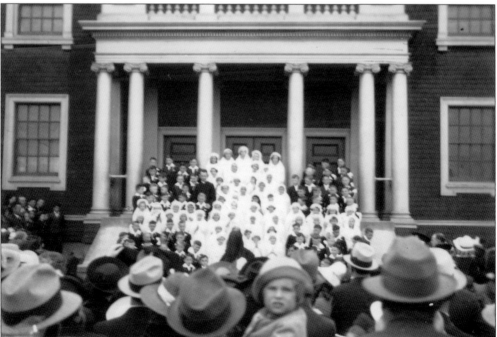

Family and friends crowd the pavement in front of the first Epiphany Church for this First Communion group in the 1920s. At the time, the parish did not have a school. Parish children attended nearby public schools or Catholic schools in other neighborhoods. (Courtesy of Annely Kelleher.)

Fr. Martin T. O'Connell, the "genial and energetic" young assistant pastor at St. John the Evangelist, died on October 19, 1918. Father O'Connell died a week after contracting influenza during the pandemic. The October 26, 1918, edition of the *Monitor* included Father O'Connell's obituary and a notice from the chief of police banning indoor religious services and permitting outdoor services if all participating wore gauze masks. (Courtesy of St. John the Evangelist Church.)

Many San Franciscans joined the service during World War I. Schools such as St. Ignatius High included lists or photographs of those serving in school publications. (Courtesy of St. Ignatius, the University of San Francisco, and the California Province of the Society of Jesus.)

1036　JAN 18 1925　JAN 18 1925　**1036**

St. James' Church
SAN FRANCISCO
Sunday Offering

AMOUNT $............................

Place your weekly offering in this envelope, seal it, and drop it on plate upon the Sunday dated above. If absent, bring this and the other envelopes that are due the first following Sunday you are present.

DO NOT BREAK SERIES

THIRD SUNDAY MONTHLY COLLECTION
— FOR —
Current Expenses

The Church Claims you. You believe in her and hope with her. She leads you to the altar of her Founder. She helps you spiritually. You help her materially.

AMOUNT $......................

Sunday collection envelopes have been a source of revenue for decades. This St. James envelope dates to 1925. It combined the first and second collection. The space is divided so that coins, not currency, fit. (Courtesy of Bernadette Hooper.)

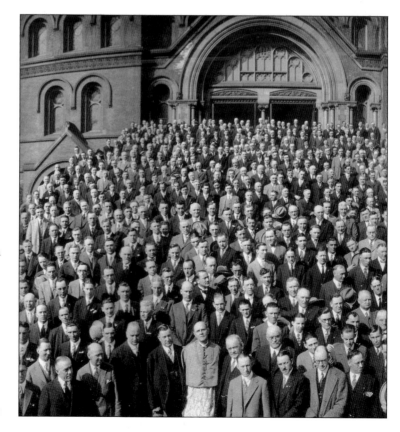

The Cathedral of St. Mary of the Assumption on Van Ness Avenue was a grand setting for many important events in the church calendar as well as civic gatherings. In 1925, the Knights of Columbus met with Archbishop Edward J. Hanna. This photograph only shows a portion of the group. (Courtesy of Bernadette Hooper.)

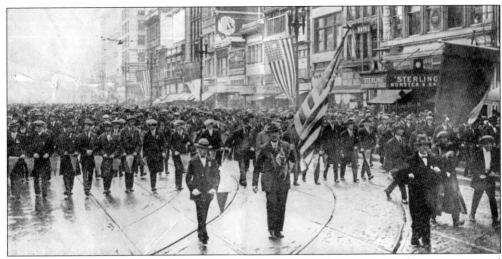

The Holy Name Parade on October 5, 1924, had a tremendous turnout of participants and onlookers from local parishes and organizations. These marchers, 1,500 strong, represent St. Paul's. The parade was organized in protest to an increase in bigotry and as a particular response to a march the Ku Klux Klan held in Washington, D.C. Newspaper accounts noted that none of the San Francisco marchers wore hoods. (Courtesy of Bernadette Hooper.)

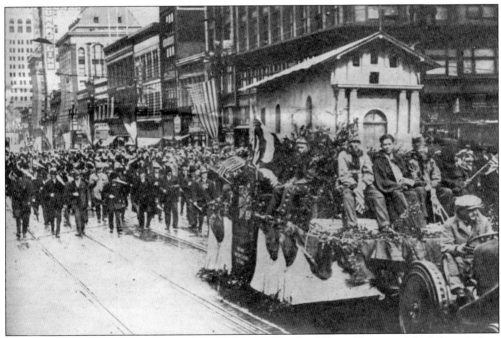

Groups from Mission Dolores lead the Holy Name Parade, followed by a model of the mission. The parade organizers recognized their parish's standing as the first place of Catholic worship in the area. (Courtesy of Bernadette Hooper.)

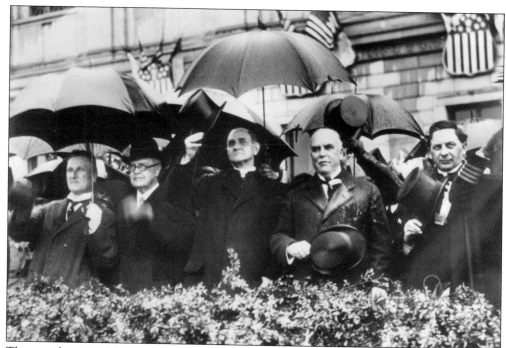

The parade route followed Market Street to the civic center. There local leaders, including Archbishop Edward J. Hanna and Mayor James "Sunny Jim" Rolph (third and fourth from left), greeted the marchers. (Courtesy of the Archives for he Archdiocese of San Francisco.)

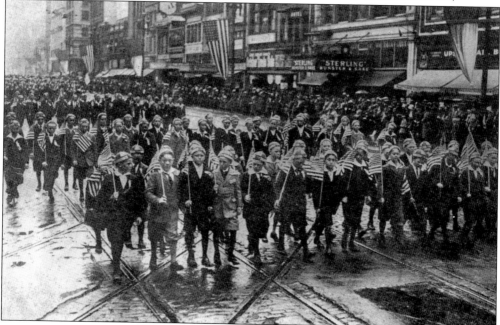

The boys of Mission Dolores also turned out for the parade. One youngster, John T. Foudy, wore a new suit that day. The weather did not cooperate; it rained. He later became Monsignor Foudy and has held many posts, including superintendent of Catholic schools. (Courtesy of Bernadette Hooper.)

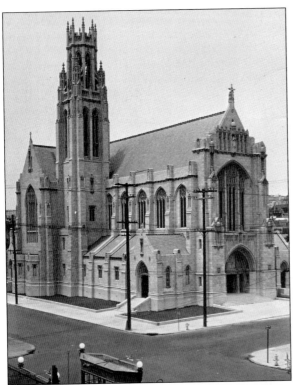

St. Dominic Church was completed in 1928. It is considered the loveliest Gothic-style church in the city. It replaced a third St. Dominic's that was wrecked by the earthquake of April 18, 1906. After the Loma Prieta earthquake of 1989, St. Dominic's undertook retrofit work with the creative solution of flying buttresses, perfect for a Gothic-style church. The latest restoration work has been to the stained-glass windows. (Courtesy of St. Dominic Church.)

The Shrine of St. Jude Thaddeus at St. Dominic Church was established during the Great Depression to inspire hope. Parishioners can attest to the steady numbers of petitioners at all hours. A blessing with a relic of St. Jude follows the weekday 5:30 p.m. Mass. (Courtesy of the Archives for the Archdiocese of San Francisco.)

Archbishop Edward J. Hanna was an outstanding civic leader known for his ability to arbitrate worker disputes and for his compassion for immigrants. On November 19, 1931, Archbishop Hanna received the American Hebrew Medal for better understanding between Jewish people and Catholics. (Courtesy of the Archives for the Archdiocese of San Francisco.)

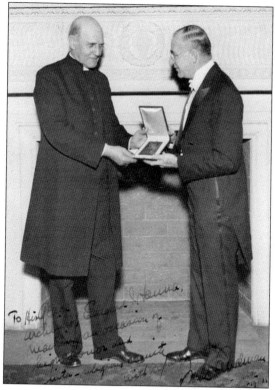

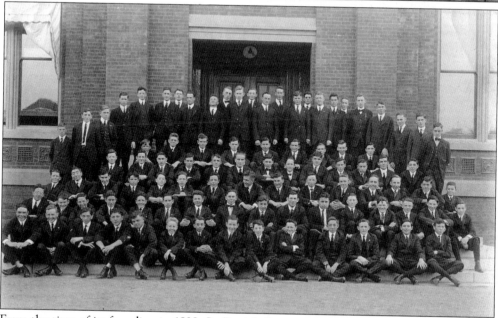

From the time of its founding in 1898, St. Patrick Seminary and University in Menlo Park has been under the direction of the Sulpician fathers. Over 2,000 priests have studied at St. Patrick's for service in the San Francisco Archdiocese and beyond. This undated class photograph was taken at a side door of the building. (Courtesy of the Archives for the Archdiocese of San Francisco.)

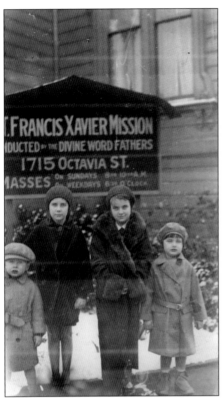

December 11, 1932, was a rare snowy day for San Francisco. It was special enough for a group photograph of neighborhood children in front of the St. Francis Xavier Mission. They are, from left to right, Joseph I. Kelly, Catherine Casey (Gas), Patricia Casey (Barnett), and Mary Ellen Kelly (Talesfore). Although they lived within the parish boundaries of St. Brigid, these children worshipped at St. Francis Xavier. (Courtesy of Fr. John Talesfore.)

The Malatesta children posed on the steps of their Richmond District home one Easter in the 1920s. Parishioners of Star of the Sea Church, they appear ready to celebrate the day. From left to right are (first row) brothers Alfred and Joseph; (second row, holding calla lilies) sisters Theresa and Dena. (Courtesy of Marie Schnell Harrington.)

Mary DeMartini and Fred Schnell married on August 3, 1923, at SS. Peter and Paul Church. Both were immigrants. Fred came from Germany at age two and Mary from Italy at 26. Their parish was a big part of their lives. Mary attended many novenas. Fred, a baker, enjoyed the sport of his adopted country, baseball. (Courtesy of Marie Schnell Harrington.)

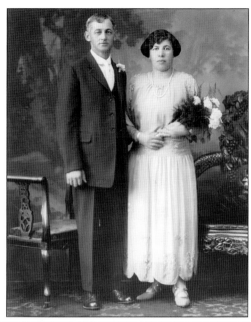

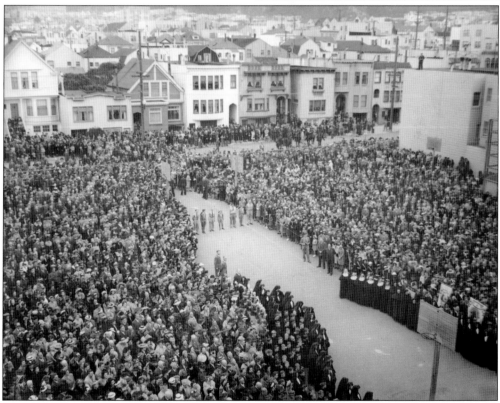

The St. Anne Novena at St. Anne of the Sunset celebrated its centennial in 2007. This photograph from the 1930s shows the thousands it drew annually. It was common for schoolchildren on summer vacation to attend the novena with several generations of their families. (Courtesy of the Archives for the Archdiocese of San Francisco.)

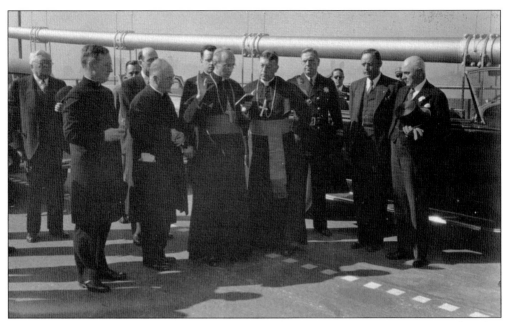

A small ceremony of blessing occurred on the San Francisco/Oakland Bay Bridge a week before it opened in 1936. Giving the blessing was Eugenio Cardinal Pacelli, later Pope Pius XII. To the left of the cardinal are Archbishop John Mitty and Francis Joseph Cardinal Spellman. At the far right is San Francisco mayor Angelo Rossi. (Courtesy of the Archives for the Archdiocese of San Francisco.)

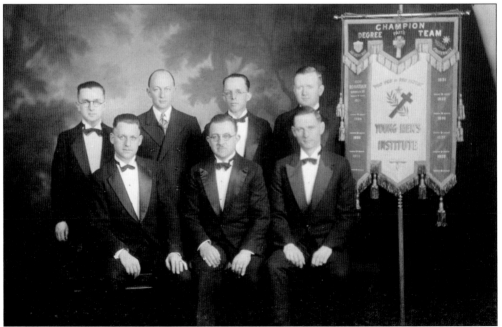

The local chapter of the Young Men's Institute (YMI) was founded in St. Joseph parish as a service organization to do good works, lend mutual support, and promote friendship. This group of YMI officers was photographed in the 1930s. (Courtesy of Archives for the Archdiocese of San Francisco.)

St. Joseph Church and parish was devastated by the earthquake and fire but rebuilt to serve the community. Children from outside the parish came to St. Joseph School. The charismatic Bishop Fulton Sheen, a friend of a longtime pastor, made many visits to St. Joseph. His talks were very popular, and savvy locals arrived early for the best seats, under the pulpit. (Courtesy of the San Francisco History Center, San Francisco Public Library.)

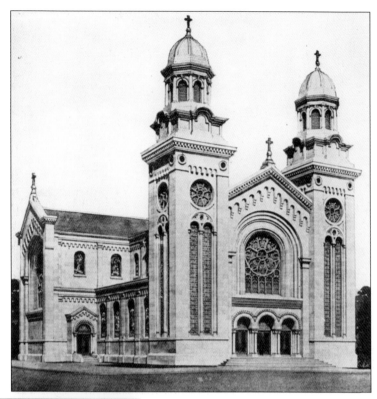

Jim Westerhouse and Winifred Doris Noonan were married on November 5, 1939, at St. Vincent de Paul Church. Jim was a graduate of St. Peter High School. Doris graduated from Star of the Sea Academy. This couple's children were born in the city. Jim retired from the San Jose Fire Department with the rank of captain. (Courtesy of the Westerhouse family.)

Boy Choristers of St. Dominic Church assembled outside the choir door on Bush Street. This group photograph dates to the 1930s or 1940s. In their time, the Choristers were well known in the city. They performed on the stage at the opera and at many hotels, including the Palace, during the holidays. Anthony Cuevas, seventh from the left, maintained a lifelong love of music. (Courtesy of St. Dominic Church)

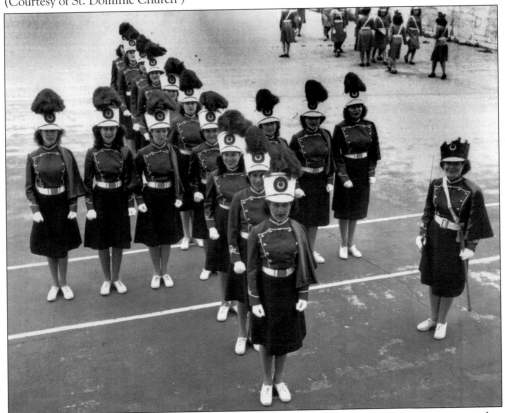

The Young Ladies Institute (YLI) had a drill team that marched in many San Francisco parades. In 1939, the YLI drill team performed at the World's Fair held on Treasure Island. To the right is drill team captain "Jo" Foley-Masino, who later taught physical education and coached at Corpus Christi Elementary School and St. John Ursuline High School. (Courtesy of the Masino/Lara family.)

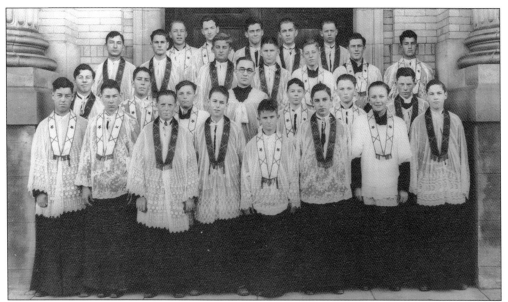

When St. Ignatius (SI) High School was on Stanyan Street, students served as altar boys at St. Ignatius Church. This 1932 photograph includes the following future Jesuits: Thomas Reed, later principal of SI, fourth row, far left; Fenton O'Toole, who wrote the SI fight song, fourth row, second from left; Charles Dullea, future University of San Francisco president, third row, second from left; Harry Carlin, future SI president, first row, third from left. (Courtesy of St. Ignatius, the University of San Francisco, and the California Province of the Society of Jesus.)

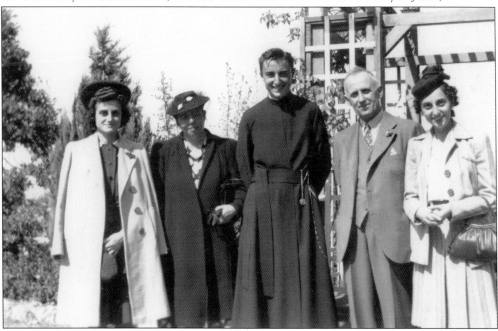

John Lo Schiavo was visited by family members while he was studying for the priesthood. As Rev. John Lo Schiavo, S.J., he was president of the University of San Francisco from 1977 to 1991. (Courtesy of St. Ignatius, the University of San Francisco, and the California Province of the Society of Jesus.)

Mary Margaret Broderick Knutsen held her daughter Paula on the day of her baptism in 1944. Paula and her sister Karen were raised on Thirty-seventh Avenue in Holy Name parish. (Courtesy of the Knutsen family.)

In 1947, proud godparents Mary Evelyn Ruane Bisazza and Gerald Ruane posed with their niece Denise Hooper on the day of her baptism at St. James Church. Siblings of the parents, close friends, and even grandparents were honored to be godparents. (Courtesy of Bernadette Hooper.)

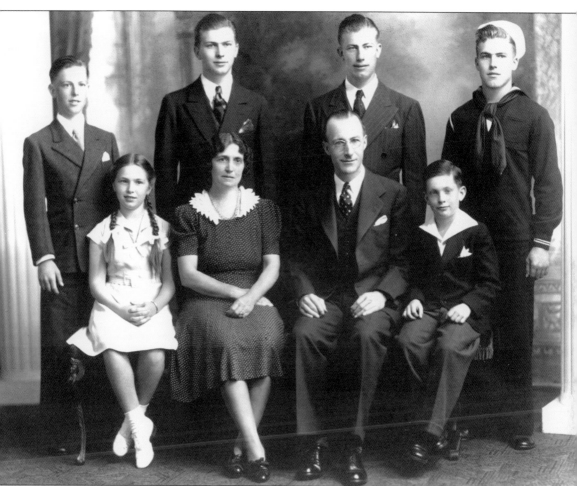

James and Artemise McKenna raised their family in St. Philip parish. Daughter Mary became a nurse, married, and had a family. Joe (first row, far right), U.S. Marine Corps, died in Korea; (second row, from left to right) George joined the USMC and retired as a lieutenant colonel; Frank, U.S. Army Air Force, died when his plane was shot down over Germany; James, USMC, was killed at Saipan; and Leo, U.S. Navy, was wounded at Guadalcanal when his ship, the USS *Astoria*, was sunk. Artemise collected donations of clothing and sent them to Maryknoll Missions for the poor of Japan and Korea. Her son Leo personally donated bundles on his many trips to the Far East while in the Merchant Marines. (Courtesy of Mary McFadden.)

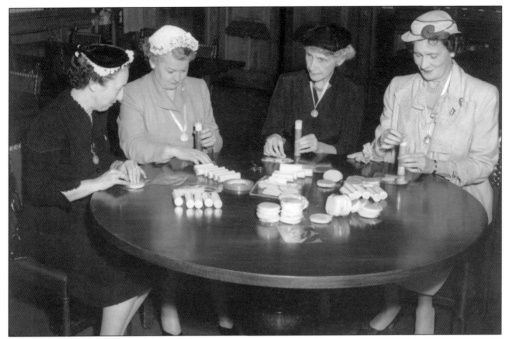

During World War II, many Catholics found ways to help the armed forces. This group met in the library at the Convent of the Sacred Heart to wrap hosts for the "Armed Forces in North and South areas." From left to right are Mrs. Parry, Anita McCarthy, unidentified, and Mrs. William Brown. Teenagers also met at the Convent of the Sacred Heart to wrap bandages. (Courtesy of Schools of the Sacred Heart Archives.)

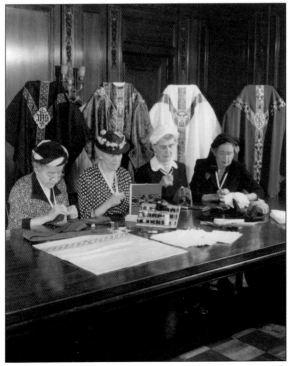

The Tabernacle Society, a group of ladies with fine needlework skills, met weekly at the Convent of the Sacred Heart to create vestments for use in the convent chapel and at local and foreign missions. The school was built in 1914 as the city residence of the James Flood family. The room reserved for the Tabernacle Society's work had formerly been James Flood's bedroom. (Courtesy of Schools of the Sacred Heart Archives.)

This crèche (or crib) was a holiday fixture next to the chapel on the first floor at the Convent of the Sacred Heart. Each student at convent had a lamb with her name affixed to it. The students were expected to observe silence during the nine days of the Christmas vigil. If they did, their lambs made their way to the crib. (Courtesy of Schools of the Sacred Heart Archives.)

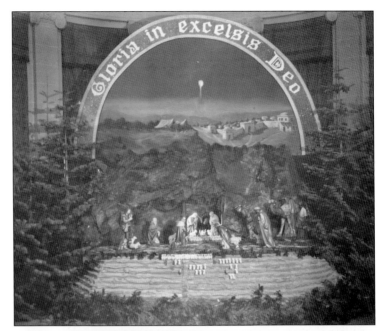

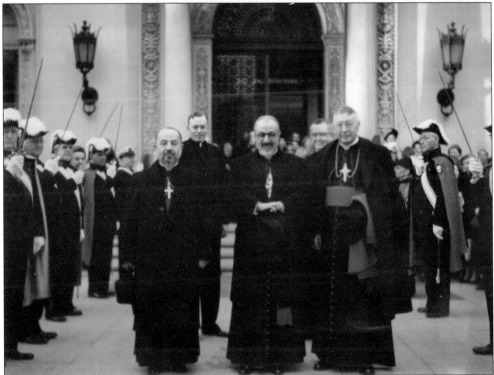

Gregoire-Pierre XV Cardinal Agagianian, patriarch of Armenian Roman Catholics of Cilicia, was honored at a reception held on January 6, 1952, at the Convent of the Sacred Heart. With the cardinal are Archbishop John J. Mitty (right), Archbishop Ignace Pierre XVI (Louis) Batanian (left), and Fr. Leo Maher (rear). The presence of a Knights of Columbus honor guard indicates that the cardinal was a very important churchman. (Courtesy of Schools of the Sacred Heart Archives.)

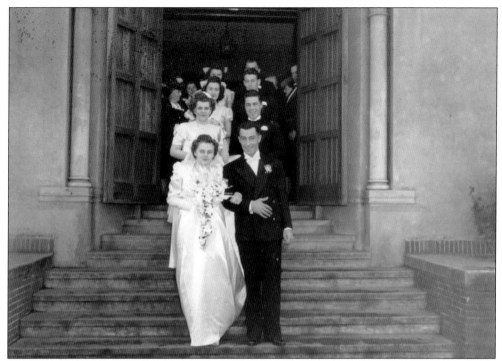

Elizabeth Zinkand and John Symkowick were married at St. Thomas Apostle Church on March 2, 1946. Among the attendants were Catherine Zinkand, sister of the bride, behind her; Evelyn Zinkand, the bride's cousin, behind Catherine; and Anthony Symkowick, the brother of the groom, behind him. The Symkowicks built a home in St. Thomas Apostle parish and remained there for the rest of their lives. (Courtesy of Kathy Symkowick.)

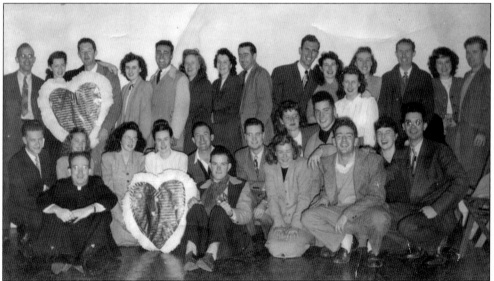

The St. Finn Barr young adults group met for a Valentine's Day party in 1948 with Fr. John Gallagher, assistant pastor. Many parishes have groups for young adults, single or married. In addition to spiritual and social events, groups also assist in service and charitable works. (Courtesy of St. Finn Barr Church.)

Sister John of the Holy Family Order and youngsters from SS. Peter and Paul parish celebrate the end of the annual summer program with a picnic and a photograph. The program, consisting mostly of arts and crafts instruction, lasted a month and was well attended. To the left of Sister John is Carmen Napolitano. Behind Sister is Flora Conti. (Courtesy of Marie Schnell Harrington.)

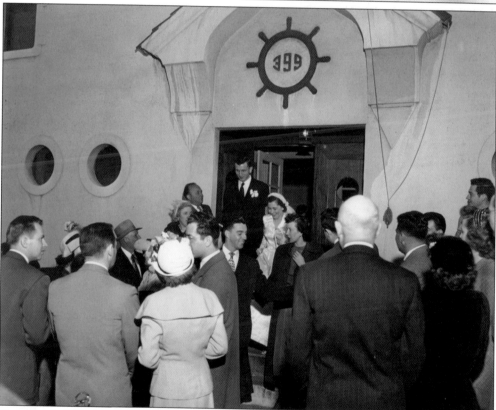

On May 4, 1951, Georgiana Meaney married Eugene Egbert at the Apostleship of the Sea, a social and spiritual gathering place for seamen. The couple met aboard the trans-Pacific liner the *President Cleveland* while Eugene was the junior assistant purser and Georgiana was a nurse working in the medical unit. Apostleship of the Sea was located at what had been the site of the original St. Brendan Church. (Courtesy of Eugene and Georgiana Egbert.)

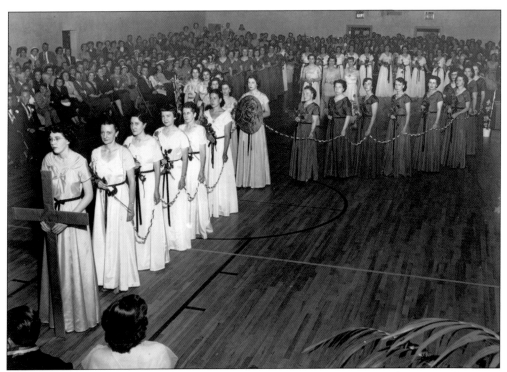

The Young Ladies Institute (YLI) was founded in San Francisco in 1887 by Annie Sweeney, Mary Richardson, and Emily Coogan as a society for beneficial and social purposes. Alberian Institute No. 93 of the Young Ladies Institute created a living rosary on the occasion of member Rose Reid's 1951 installation as grand president of the YLI. The Alberian Institute continues to meet at Corpus Christi Church. (Courtesy of the Alberian Institute No. 93.)

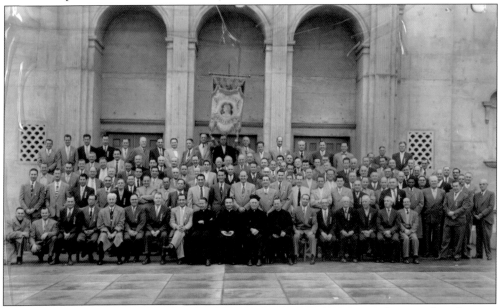

The Holy Name Society of the Church of the Epiphany poses for a group photograph in January 1954. (Courtesy of Church of the Epiphany/Miles Butcher.)

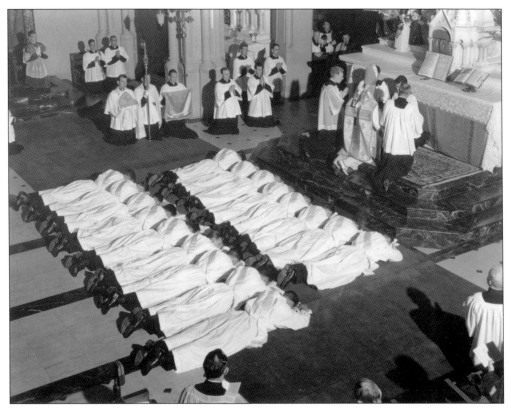

St. Mary's Cathedral on Van Ness Avenue was the site of many religious celebrations since its founding in 1891. On June 17, 1956, a group of young men were ordained into the priesthood. (Courtesy of the Archives for the Archdiocese of San Francisco.)

An ordination of priests at St. Mary's Cathedral took place in 1956. (Courtesy of the Archives for the Archdiocese of San Francisco.)

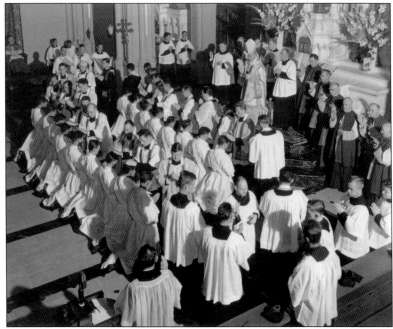

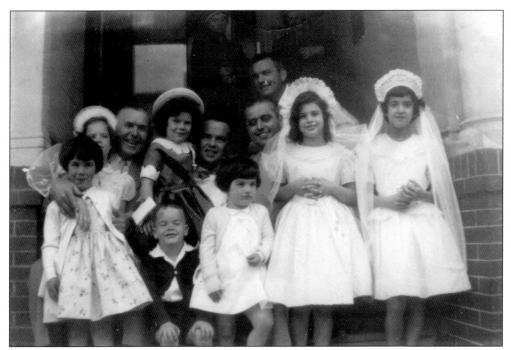

From left to right, cousins Denise Hooper, Kathleen Bisazza, and Joan Alioto made their First Communion at St. James Church on the same day in 1955. Celebrating with them are one grandfather, two fathers, one uncle, siblings, cousins, and (at the top of the stairs) two grandmothers. (Courtesy of Bernadette Hooper.)

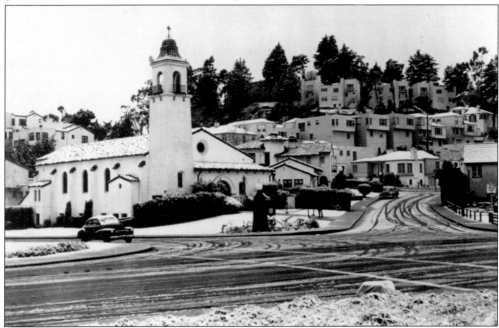

St. Brendan Church had a rare dusting of snow on February 28, 1951. Snow is such a rare sight in the city that a framed copy of this photograph hangs in the parish office. (Courtesy of St. Brendan School.)

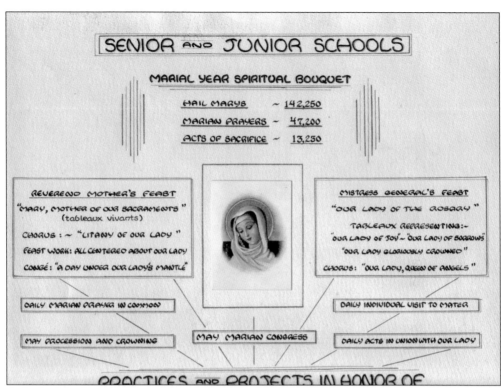

SENIOR AND JUNIOR SCHOOLS

MARIAL YEAR SPIRITUAL BOUQUET

HAIL MARYS ~ 142,250
MARIAN PRAYERS ~ 47,200
ACTS OF SACRIFICE ~ 13,250

REVEREND MOTHER'S FEAST
"MARY, MOTHER OF OUR SACRAMENTS"
(tableaux vivants)
CHORUS:~ "LITANY OF OUR LADY"
FEAST WORK: ALL CENTERED ABOUT OUR LADY
CONGÉ: "A DAY UNDER OUR LADY'S MANTLE"

MISTRESS GENERAL'S FEAST
"OUR LADY OF THE ROSARY"
TABLEAUX REPRESENTING:-
"OUR LADY OF JOY"~ "OUR LADY OF SORROWS"
"OUR LADY GLORIOUSLY CROWNED"
CHORUS: "OUR LADY, QUEEN OF ANGELS"

DAILY MARIAN PRAYER IN COMMON
DAILY INDIVIDUAL VISIT TO MATER
MAY PROCESSION AND CROWNING
MAY MARIAN CONGRESS
DAILY ACTS IN UNION WITH OUR LADY

PRACTICES AND PROJECTS IN HONOR OF

A draft of the Spiritual Bouquet for the Marian year, 1954, by the students at the Convent of the Sacred Heart, shows many prayers and good works. The final draft, with spelling correction, was probably presented to Reverend Mother. (Courtesy of Schools of the Sacred Heart Archives.)

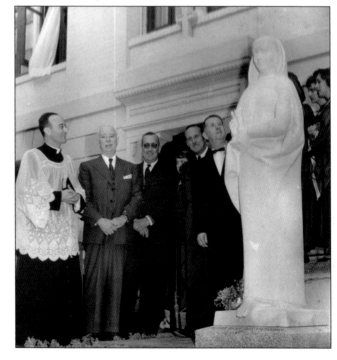

On March 21, 1958, Fr. Julian Marquis presided over the dedication of a statue of Our Lady at Notre Dame des Victoires Church. In attendance were parishioners, students, the French consul general, and members of the French American community. (Courtesy of the Archives for the Archdiocese of San Francisco.)

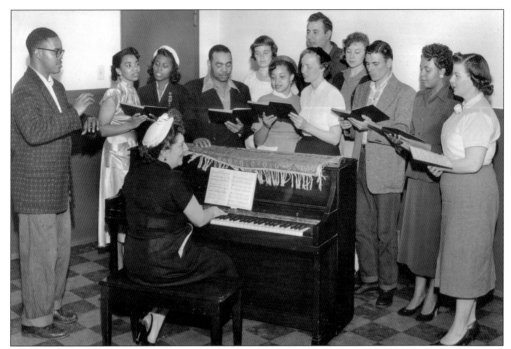

Choir practice brings out the dedication and talents of parishioners. The choir of Our Lady of Lourdes Church was photographed at practice in 1956. (Courtesy of St. Paul of the Shipwreck.)

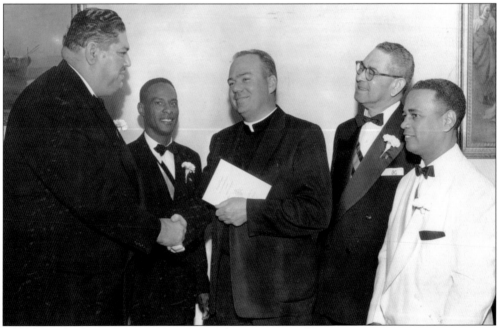

The Knights of St. Peter Claver of San Francisco, a black Catholic organization, gathered for this 1956 photograph. Formed in 1900, the group honors the work of the saint who ministered for 44 years to the people brought for sale to the slave market in Cartagena. Peter Claver was canonized in 1888. (Courtesy of the Archives for the Archdiocese of San Francisco.)

Mary Fisher stood on the steps of St. Monica Church for this photograph with Msgr. William J. Cantwell in 1955. Monsignor Cantwell was pastor from 1929 to 1962. Fisher was a teacher and the first president of the Legion of Mary in San Francisco. She attended the last Mass at the first St. Monica's Church and the first Mass at the current location, on the same day. (Courtesy of Olivia Fisher.)

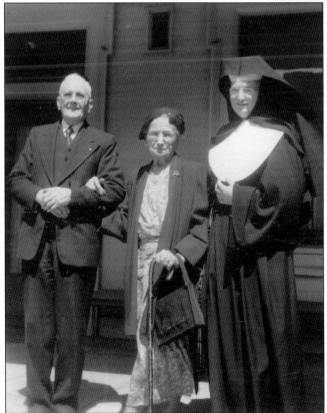

Sr. Marie Therese Theis, P.B.V.M., was photographed with her parents, Anna Gruhn and Adolph Theis, on their diamond wedding anniversary. Sister taught at many Presentation Order schools in San Francisco and San Jose. In her retirement, she fulfilled her dream of showmanship by performing in musicals staged for members of her order. Sister's most memorable performance was the title role in *Hello, Dolly!* Sister lived to be 100. Her motto was, "She who laughs, lasts." (Courtesy of Frank Dunnigan.)

St. Teresa Church and rectory was photographed in the early 1950s. The church was originally situated at Nineteenth and Tennessee Streets. After the earthquake and fire of 1906, many people moved away from the area when it became industrialized. In 1924, the pastor bought the property at Nineteenth and Connecticut Streets and had the church moved. (Courtesy of St. Teresa parish.)

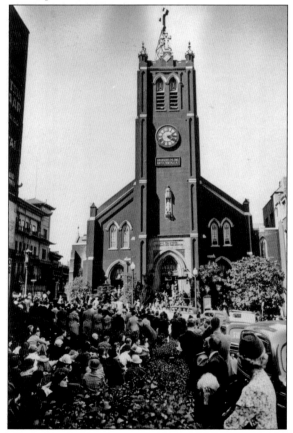

Old St. Mary's Church on California Street has a very active parish life normally. Attendance jumps even higher on Holy Days of Obligation, when workers from the Financial District and tourists attend services. This photograph was probably taken on Good Friday. (Courtesy of the Archives for the Archdiocese of San Francisco.)

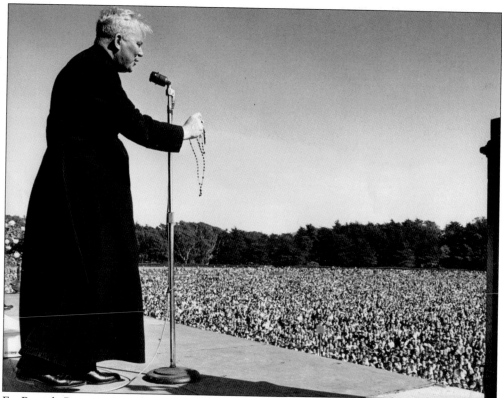

Fr. Patrick Peyton, CSC, led more than half a million Catholics in praying the Rosary on October 7, 1961, at the Polo Field in San Francisco's Golden Gate Park. Many families were eager to participate in this event, and a few were chosen to help recite the five Glorious Mysteries. (Courtesy of the Archives for the Archdiocese of San Francisco.)

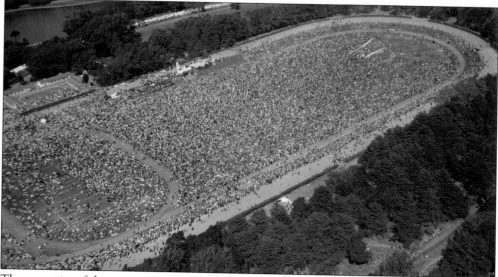

The enormity of the participation in the Rosary Crusade of 1961 can be witnessed in this aerial view. Father Peyton's arrival by helicopter matched the grandeur of the event. (Courtesy of St. Gabriel School.)

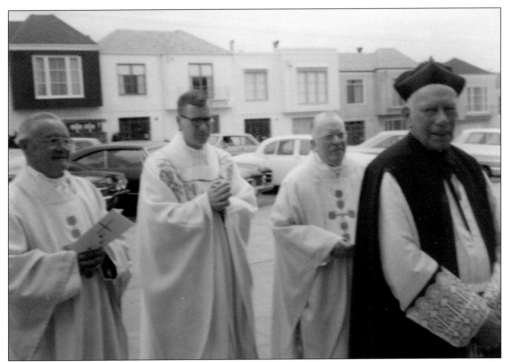

Fr. Gerald Coleman celebrated his first Mass at his St. Gabriel Church on May 19, 1968. (Courtesy of St. Gabriel School.)

Fr. Vincent D. Ring (right) celebrated his first Mass at his childhood church, St. Anne of the Sunset, in 1964. Congratulating him and possibly giving him the benefit of their experience are Msgr. Henry Lyne (left), pastor of Most Holy Redeemer Church, and his assistant pastor, Fr. John. K. Ring, Fr. Vincent D. Ring's brother. (Courtesy of Fr. John K. Ring.)

The Italian Catholic Federation (ICF) presented Archbishop Joseph T. McGucken with a Spiritual Bouquet at an Archbishop's Day gathering. From left to right are Msgr. Joseph Munier, a Knight of St. Gregory; Luigi Providenza, an ICF founder; Archbishop McGucken; the Honorable Paolo Molajoni, the consul general of Italy; Albert Teglia, ICF grand president; William Regis; Ario Gregori; and Mario Cugia, chairman for Archbishop's Day. (Courtesy of the Archives for the Archdiocese of San Francisco.)

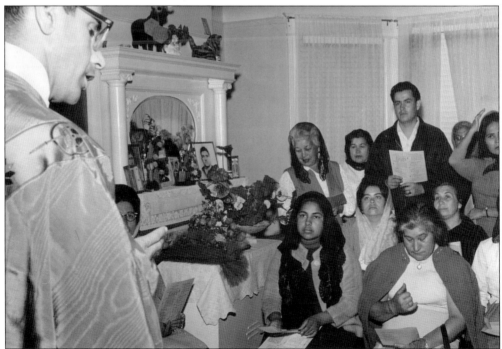

St. Charles Borromeo parishioners celebrated Mass at a home on September 22, 1966. The Mass was a "lunta de vecindad," which started with a weekly meeting at a host house and included a recitation of the Rosary in Spanish. (Courtesy of the Archives for the Archdiocese of San Francisco.)

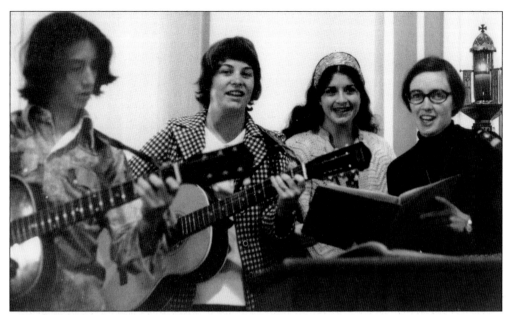

This youthful group at St. Kevin Church in 1975 was probably performing contemporary music for a "Folk Mass." (Courtesy of the Archives for the Archdiocese of San Francisco.)

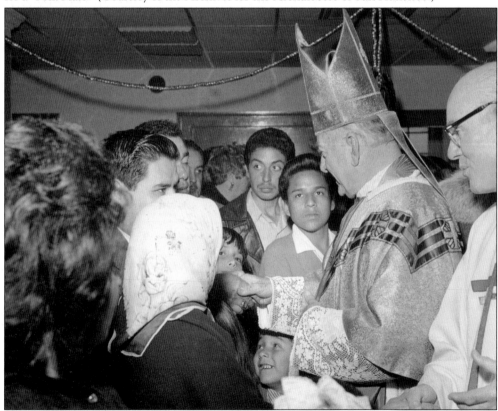

St. Kevin's parish celebrated its 50th anniversary at a reception with Archbishop Joseph McGucken in May 1972. (Courtesy of the Archives for the Archdiocese of San Francisco.)

The parish of St. Patrick has seen many dramatic changes. It began with a largely Irish immigrant population, then experienced the destruction of the 1906 earthquake and fire and the deterioration of the neighborhood in later years. Now it is a treasured part of a revitalized South of Market (SOMA) and a spiritual home to other immigrant groups, most especially the Filipino community. (Courtesy of the Archives for the Archdiocese of San Francisco.)

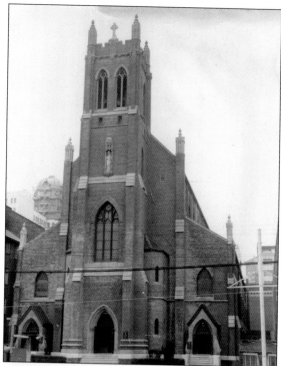

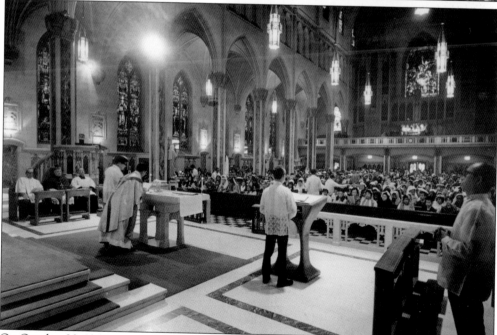

On October 30, 1964, members of the Filipino Catholic community came together for Mass at St. Patrick Church on Mission Street. St. Patrick's was established in 1851 for the Irish immigrant community. Its decorations include marble from Connemara. For decades, St. Patrick's has been the unofficial Filipino National Church. (Courtesy of the Archives for the Archdiocese of San Francisco.)

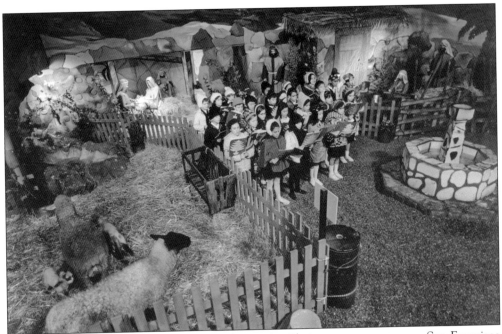

The crib (or crèche) was a popular feature during the Christmas season at many San Francisco churches. The crib at St. Boniface Church, photographed on December 18, 1969, was a sentimental favorite because it had live animals. Thomas Fealy chose it as the spot to propose to Patricia Ruane in 1950. (Courtesy of the Archives for the Archdiocese of San Francisco.)

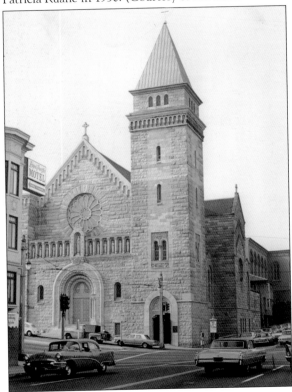

Shown here in the mid-20th century, St. Brigid Church on Van Ness Avenue at Broadway was the heart of a bustling parish community. The parish was formed in 1863; it closed in 1994. The elementary school remains open. The beautiful main doors were rarely opened. They are so heavy that opening them took special permission and care. The church building became San Francisco Landmark No. 252 on October 24, 2006. (Courtesy of the Archives for the Archdiocese of San Francisco.)

Early morning mass at St. Ignatius Church in fall 1968 was celebrated by the Reverend Harry V. Carlin, S.J., president of St. Ignatius High School. At this Mass, the altar server was Kevin Leidich, now Rev. Kevin Leidich, S.J. Sanctuary society members, such as Leidich, collected altar linen from the Carmelite nuns at the Monastery of Chisto Rey. (Courtesy of Frank Dunnigan.)

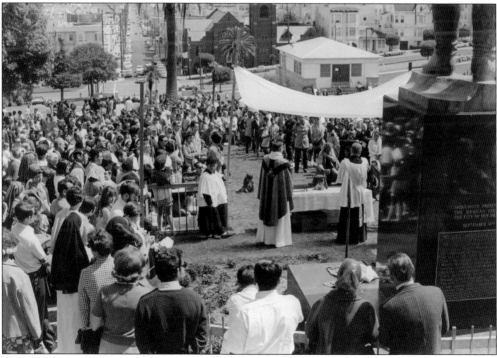

A large group of supporters of the boycott in aid of the United Farm Workers attended Mass at Dolores Park on September 12, 1968. (Courtesy of the Archives for the Archdiocese of San Francisco.)

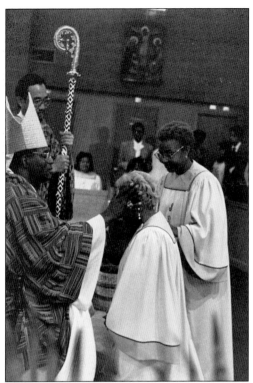

Bishop Wilton D. Gregory of Belleville, Illinois, (now the archbishop of Atlanta) visited St. Paul of the Shipwreck Church. Here he gives a blessing to members of the church choir. (Courtesy of St. Paul of the Shipwreck.)

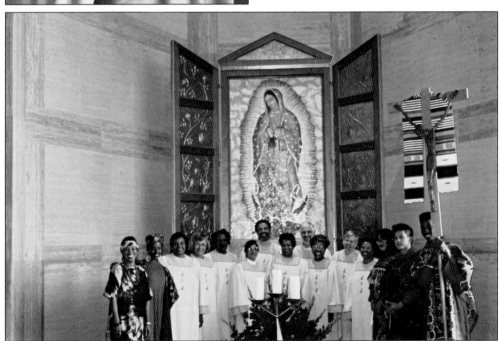

The choir of St. Paul of the Shipwreck was photographed in front of the Shrine to Our Lady of Guadalupe at St. Mary's Cathedral. It is said that the shrine was promised to Our Lady by Msgr. Thomas J. Bowe, who headed the fund-raising for the cathedral's construction. (Courtesy of St. Paul of the Shipwreck.)

The interior of the Cathedral of St. Mary of the Assumption includes a sculpture by Richard Lippold above the altar. (Courtesy of the Archives for the Archdiocese of San Francisco.)

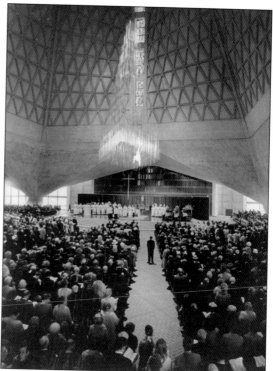

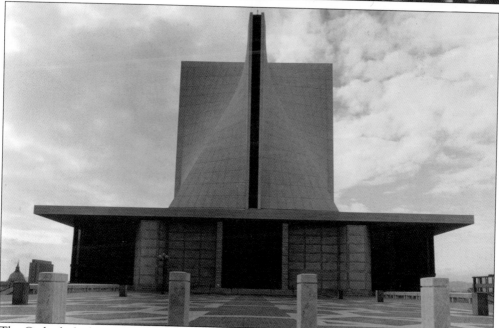

The Cathedral of St. Mary of the Assumption on Geary Boulevard was blessed on May 5, 1971. It is the design of architect Pietro Belluschi and engineer Pier-Luigi Nervi. This is the third cathedral of that name in San Francisco. The first is now called Old St. Mary's. The second cathedral was constructed on Van Ness Avenue in 1891 and was destroyed by fire in 1962. (Courtesy of the Archives for the Archdiocese of San Francisco.)

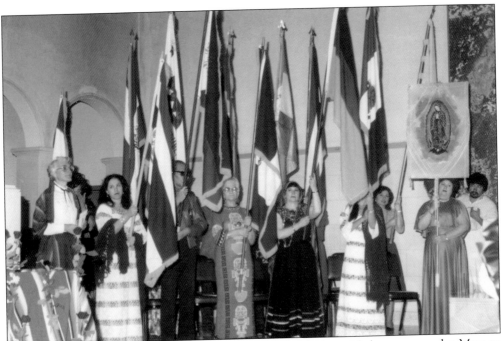

Since 1976, the Latin American community of St. Elizabeth parish has sponsored a Mass to honor Our Lady of Guadalupe. In 1984, people from Latin American countries gathered on the altar of St. Elizabeth holding flags. The celebration began with a procession into the church led by a mariachi band and ended with a dramatization of the apparition of Our Lady to Juan Diego. (Courtesy of the Latin American community of St. Elizabeth.)

In the 1970s and 1980s, many fled El Salvador to escape the civil war. Several Bay Area Catholic churches made commitments to shelter these refugees. In March 1986, pastor Fr. Maurice McCormick presided over the ceremony designating St. John of God as a Sanctuary Church. (Courtesy of St. John of God.)

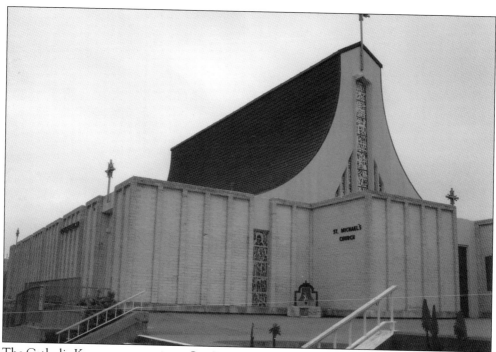

The Catholic Korean community in San Francisco began with a pastoral mission at the old Holy Cross parish church. In 1994, the community moved to St. Michael's parish and reopened it as St. Michael Korean parish. (Courtesy of David R. Mehrwein.)

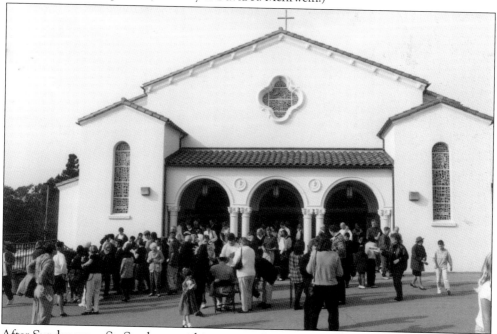

After Sunday mass, St. Stephen parishioners mingle outside church. Architect Fred Houweling Jr. designed the church in the Spanish mission style. Local artist Carl Huneke created 32 stained-faceted windows in the church, including six in the sanctuary. He has designed windows for more than 70 churches in California. (Courtesy of St. Stephen Church.)

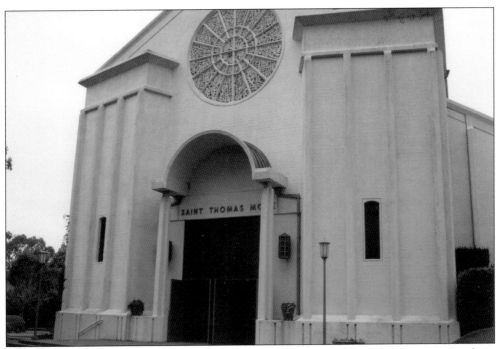

St. Thomas More Church is a multicultural parish that serves the Arab, Asian, Brazilian, Burmese, Filipino, Hispanic, Irish, Italian, and other Catholic faith communities with Mass offered in four languages. The church also serves as the campus ministry for the Newman Center, serving the students at San Francisco State University. (Courtesy of David R. Mehrwein.)

Mass Schedule:
8:00 a.m. Every Day
5:00 p.m. Saturday
10:00 a.m. Sunday

Plus...

AIDS Support Group • AIDS in Africa • Outreach
Community Life • Education • Peace & Social Justice
Wednesday Suppers for the Homeless • Children's Program
Small Faith Groups • Reconnecting for Returning Catholics
Ministry to the Homebound • Music Program
Outreach to the Poor • Rite of Christian Initiation for Adults
Diamond Senior Center • Young Adults Group
And Much, Much More...

Most Holy Redeemer Catholic Parish
100 Diamond Street (at 18th Street)
in San Francisco's Castro District
http://www.mhr.org • (415) 863-6259

A recent list of parish devotions, groups, and activities shows the wide range of interests and outreach of the Most Holy Redeemer community. Charitable works are a high priority, including the Wednesday night suppers for the poor. At a recent Pride Parade, a group of marchers from the parish wore T-shirts with "MHR" on the front and "The face of the Church in the 21st century" on the back. (Courtesy of Most Holy Redeemer Church.)

The First Communion Class of St. Peter School of Religion gathered around Fr. Daniel Maguire, pastor, as he celebrated Mass. For several years after a 1998 fire gutted the church, services were held in the former St. Peter High School auditorium. (Courtesy of Fr. Daniel Maguire.)

Many parishes have RCIA (Rite of Christian Initiation for Adults) programs. This group, with their sponsors, posed on the steps of St. Vincent de Paul Church in 1998. (Courtesy of Fr. John K. Ring.)

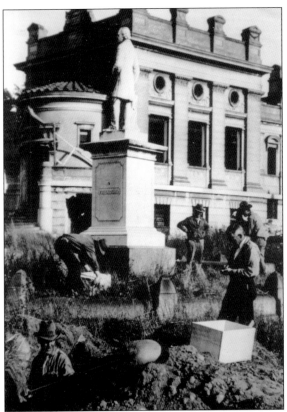

As land became more valuable in the city of San Francisco, the cemeteries were relocated to other parts of the Bay Area, most notably in Colma. In 1939, the removal of remains from Mount Calvary Cemetery began. (Courtesy of the Archives for the Archdiocese of San Francisco.)

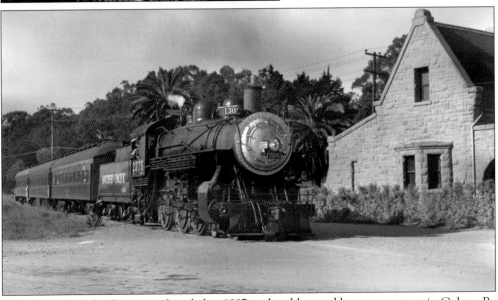

Holy Cross Catholic Cemetery, founded in 1887, is the oldest and largest cemetery in Colma. By 1891, Southern Pacific Railroad sent two scheduled trains daily to Holy Cross Cemetery to carry caskets and mourners. Many notable politicians, bankers, civil servants, and Catholic religious figures are buried here. The cemetery currently has over 300,000 interred within its grounds. (Courtesy of Holy Cross Catholic Cemetery, Colma, California.)

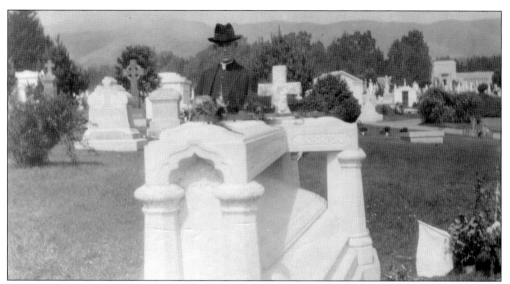

Fr. Ralph Hunt, a close friend of Fr. Peter Yorke, stands by Yorke's grave at Holy Cross Cemetery in Colma. Every year since Father Yorke's death on Palm Sunday 1925, the United Irish Societies of San Francisco sponsors a commemorative Mass honoring him. It is Colma's longest running memorial pilgrimage for an individual. (Courtesy of the Archives for the Archdiocese of San Francisco.)

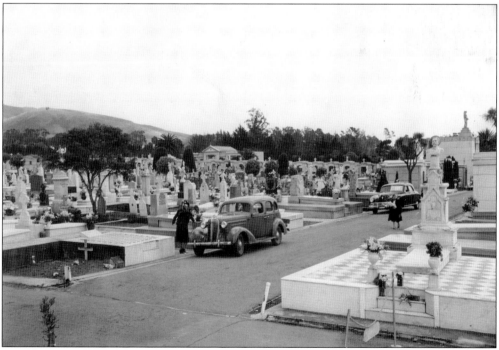

The Italian Cemetery in Colma was established in 1899 by the Italian Mutual Benevolent Society to serve the Italian community. To the right of this 1948 photograph is the monument to Francesco Calegari. The bas-relief under his picture is that of his daughter-in-law, Eugenia. The Italian translation of the inscription reads, "taken away in the flower of life by accidental misfortune." (Courtesy of the Italian Cemetery.)

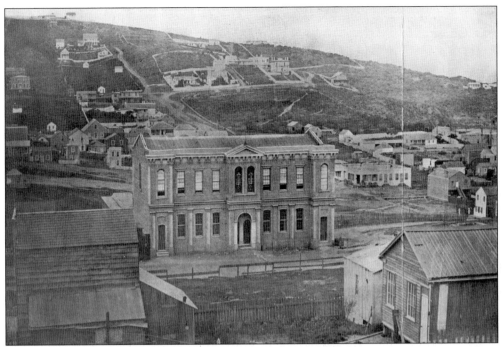

Presentation Convent at Powell and Lombard Streets was founded in 1855 by the Sisters of the Presentation of the Blessed Virgin Mary for the education of girls. (Courtesy of Presentation Archives, San Francisco.)

St. Rose Academy, a school for Catholic girls and later a high school, was founded by the Dominican Sisters of San Rafael in 1864. This is the first location of the school in the South of Market area. Its final location was on Pine Street at Pierce Street. (Courtesy of the Archives for the Archdiocese of San Francisco.)

Two

HOPE

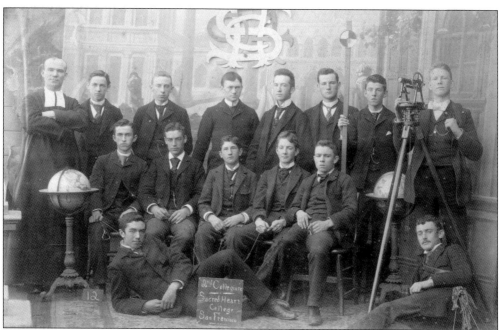

Sacred Heart High School is one of the city's oldest Catholic secondary schools established for boys. Founded by the Christian Brothers, the curriculum is firmly college preparatory. At the time this photograph was taken, the curriculum included at least one applied science—surveying—and commercial classes. The school, now Sacred Heart Cathedral Preparatory, has been coeducational since 1987. (Courtesy of the De La Salle Institute.)

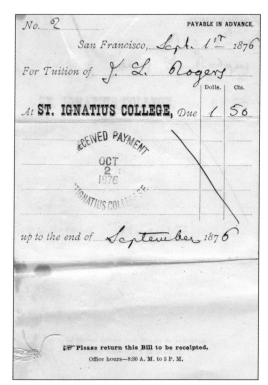

Education at St. Ignatius College has always been valued. Tuition for September 1876 was $1.50. (Courtesy of St. Ignatius, the University of San Francisco, and the California Province of the Society of Jesus.)

This St. Ignatius rugby team played in a match with Sacred Heart High School on St. Patrick's Day in 1893. Since then, the schools have maintained the longest running high school sports competition west of the Rockies. (Courtesy of St. Ignatius, the University of San Francisco, and the California Province of the Society of Jesus.)

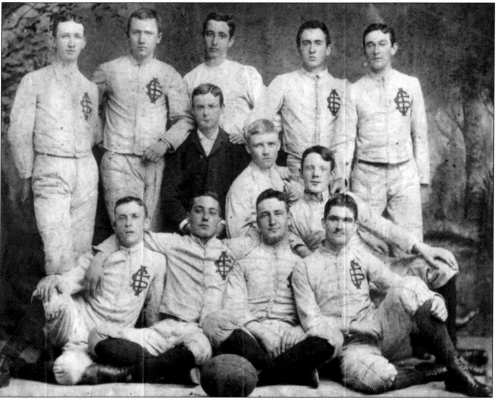

Charlotte McFarland wanted an education, although her aunt did not approve of it for females. Charlotte was tutored by Rev. Anthony Maraschi, S.J., of St. Ignatius. She was not technically St. Ignatius's first coed; that change had to wait until 1989. (Courtesy of St. Ignatius, the University of San Francisco, and the California Province of the Society of Jesus.)

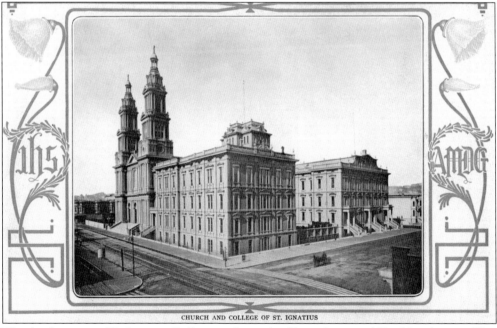

CHURCH AND COLLEGE OF ST. IGNATIUS

The third campus of St. Ignatius College was located at Hayes Street and Van Ness Avenue. This 1880 photograph contains two Latin inscriptions: IHS, for the first three letters of Jesus' name in Greek; and A.M.D.G. for Ad Majorem Dei Gloriam, "For the Greater Glory of God." To this day, students at St. Ignatius College Preparatory write A.M.D.G. at the top of their assignments. (Courtesy of St. Ignatius, the University of San Francisco, and the California Province of the Society of Jesus.)

Josephine Creem was born in San Francisco at 105 Townsend Street. She graduated from Presentation Convent on Powell Street in 1898. This photograph shows her wearing her graduation pin marked with the year. It is still in the possession of her grandson. Josephine lived in many parishes during her lifetime: St. Rose, St. James, Mission Dolores, St. Agnes, and St. Cecilia. (Courtesy of Frank Dunnigan.)

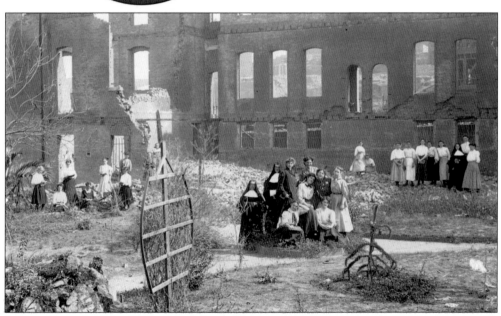

In the aftermath of the 1906 earthquake and fire, sisters and students stood in the ruins of the Presentation Convent in North Beach. (Courtesy of Presentation Archives, San Francisco.)

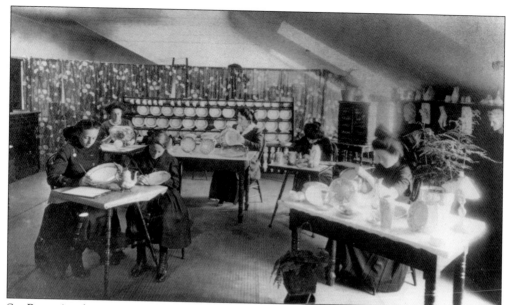

St. Rose Academy is recalled as a fine college preparatory school. In its earlier years, the curriculum included china painting, as shown in this 1910 photograph. Graduates have entered diverse professions. (Courtesy of the Archives for the Archdiocese of San Francisco.)

Notre Dame de Namur, on Dolores Street, was a school for girls. One 1912 graduate was Helen ("Nell") McEnnerney, late of Leadville, Colorado. Nell applied the skills she learned from the Notre Dame Sisters to a lifelong career at the phone company. (Courtesy of the McEnnerney family.)

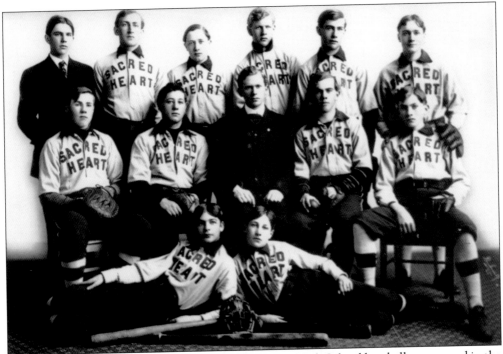

Proud of their achievements in sports, this Sacred Heart High School baseball team posed in the early years of the 20th century. (Courtesy of Sacred Heart Cathedral Preparatory.)

Nowadays most Catholic schools are staffed by non-religious lay teachers. Lay teachers were rare when this photograph of St. Peter's School teachers was taken. May (Mary Elizabeth) Wallace (second from left) taught at the school after her 1909 graduation from Notre Dame de Namur High School. She left to marry in 1916. Three of her grandchildren have taught at local Catholic schools. (Courtesy of De La Salle Institute.)

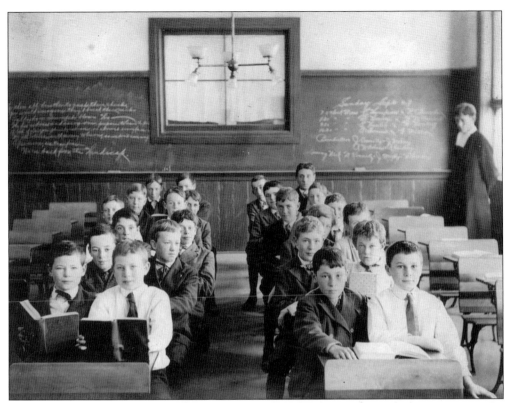

A St. Peter Boys School class doubled up at their desks for this picture with their instructor, Br. Ulrick Michael (Thomas Ruane). Brother Michael taught at St. Peter's in 1914 and 1917. Prior to entering the Christian Brothers, he had been a mason and had worked to clear the debris in the city after the 1906 earthquake and fire. (Courtesy of De La Salle Institute.)

The St. Peter Boys School basketball team and coach perfected their poise for this photograph in October 1911. There are no records of how they did on the court. (Courtesy of De La Salle Institute.)

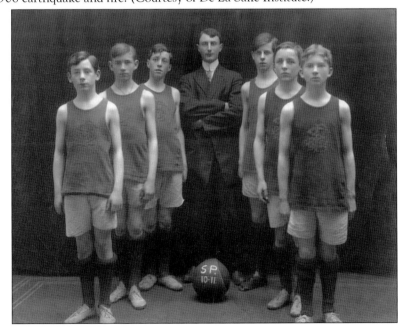

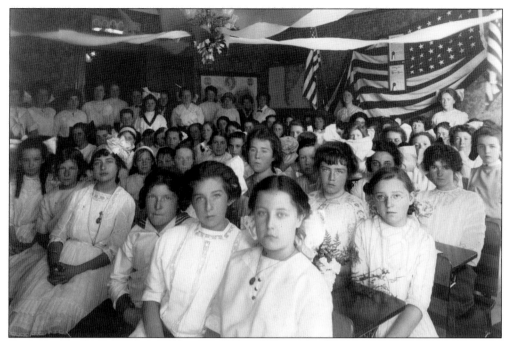

Students of a class at St. Agnes School in 1910 had this rare indoor image. Their instructors were the Sisters of the Presentation of the Blessed Virgin Mary. (Courtesy of Presentation Archives, San Francisco.)

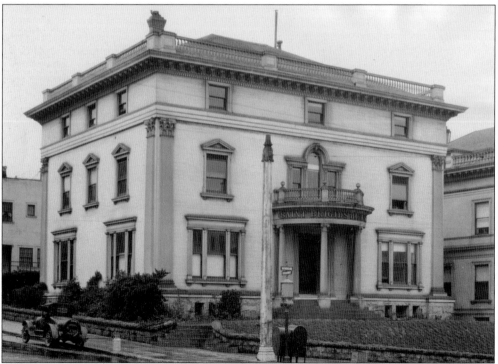

St. Brigid (Girls) High School occupied the northwest corner of Van Ness Avenue and Broadway. It closed in 1953. (Courtesy of Archives for the Archdiocese of San Francisco.)

The 1914 class of Star of the Sea High School had the distinction of being coeducational. Grace Cecelia Allen (center) became famous as part of the comedy team of Burns and Allen with her husband, George Burns. Both were generous to her alma mater. (Courtesy of Star of the Sea School.)

William Thomas Byrne Winifred Catherine Sheridan Mary Elizabeth Lynch

Mary Helen Dowd Grace Cecelia Allen Josephine Ann Moriarity

Edward Albert Conlon Claire Agnes Stealey Kathryn Mary Parker

Mary Helen Moriarity Laura Mercedes Ronstadt Romietta Claire Dever

Immaculate Conception Academy was founded in 1883 by Sr. Maria Pia Backes, O.P., and continues to offer a college preparatory education to young women. In this charming portrait, the class of 1925 shows off their finery. (Courtesy of the Archives of the Dominican Sisters of San Jose–Immaculate Conception Academy.)

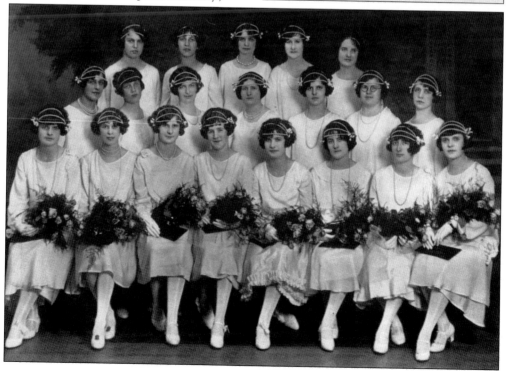

Joseph McNeil (third row, second from right) was born in 1898 and attended the eighth grade at St. Ignatius when it was on Hayes Street. He later had a career as a commercial lithographer and married Ellen Redding of Nicasio. (Courtesy of Mary Ellen McNeil Hoffman.)

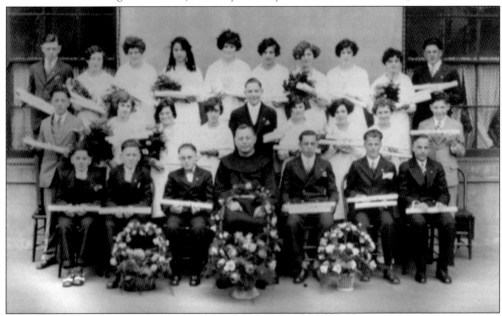

St. Anthony School eighth-grade class of 1927 celebrated with a picture. Fr. Martin Knauff, O.F.M., (front) was their pastor. Frank Portman, later a contractor and supporter of many Catholic organizations, stands behind Father Martin. (Courtesy of St. Anthony/Immaculate Conception School.)

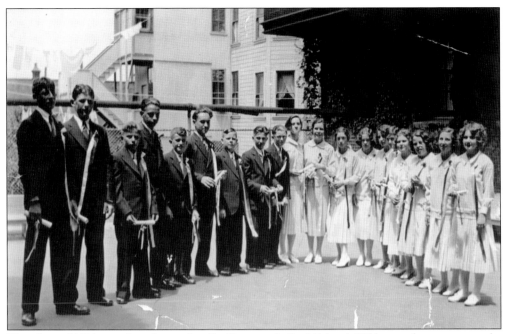

The class of 1931 posed in the yard at St. Vincent de Paul School. Ribbon sashes were worn by outstanding students. (Courtesy of St. Vincent de Paul Church.)

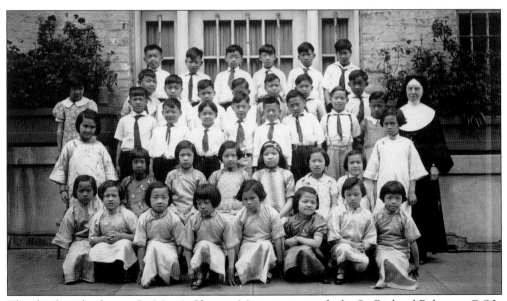

The third-grade class at St. Mary's Chinese Mission was taught by Sr. Richard Belanger, C.S.J., in 1935. (Courtesy of the Sisters of St. Joseph of Orange.)

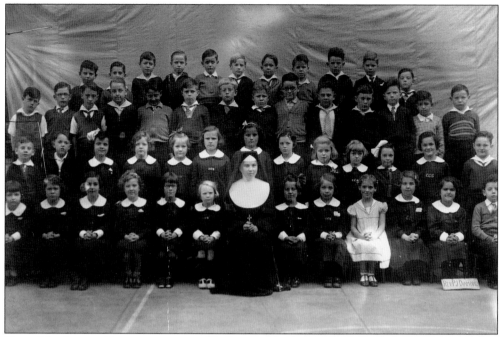

One of the first teaching assignments of Sr. Rosalia Haring, C.S.J., was at Corpus Christi School. She is shown here with the second-grade class of 1936–1937. (Courtesy of the Sisters of St. Joseph of Orange.)

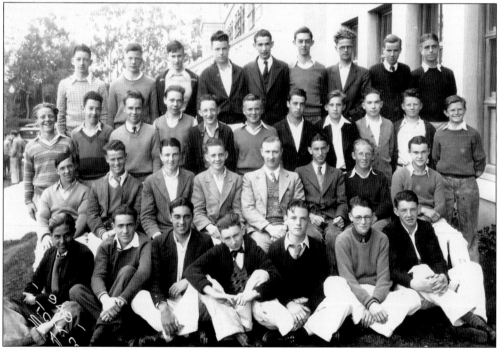

St. Ignatius High School students posed in the yard of the Stanyan Street school for this 1949 photograph. (Courtesy of St. Ignatius, the University of San Francisco, and the California Province of the Society of Jesus.)

The Parish Picnic for St. John the Evangelist was held in Menlo Park on Sunday, August 21, 1938. The picnic flyer contained an advertisement to "Make Murphy Governor." Daniel Murphy did not become governor. (Courtesy of St. John the Evangelist Church.)

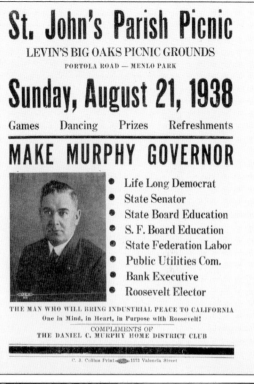

Parishioners of St. Finn Barr enjoyed their 1933 parish picnic. Some parishes left town for these events, but this one appears to be in Balboa Park. In the days before the 280 Freeway split the neighborhood, the park would have been a pleasant stroll from the church. (Courtesy of St. Finn Barr Church.)

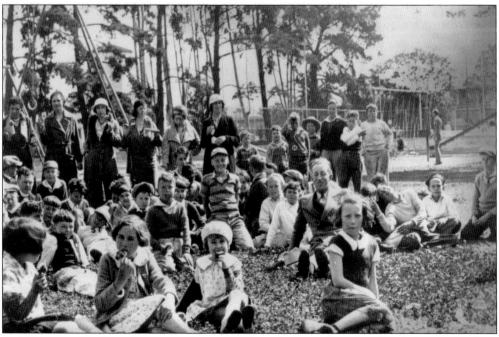

After the earthquake and fire, St. Ignatius High School and College (later the University of San Francisco) occupied buildings on Hayes Street across from St. Mary's Hospital. The school was affectionately called the Shirt Factory, perhaps for its resemblance to some quickly built factories of the era. (Courtesy of St. Ignatius, the University of San Francisco, and the California Province of the Society of Jesus.)

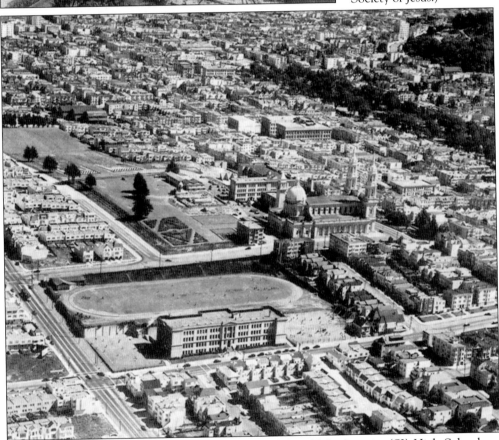

The University of San Francisco (USF) campus and the old St. Ignatius (SI) High School are shown in this view taken before World War II. USF has added many buildings over time and expanded to the former Lone Mountain College campus and the old Presentation High School buildings. St. Ignatius left Stanyan Street in 1969 for extensive property in the Sunset District. Their building was replaced by USF's Koret Center. (Courtesy of St. Ignatius, the University of San Francisco, and the California Province of the Society of Jesus.)

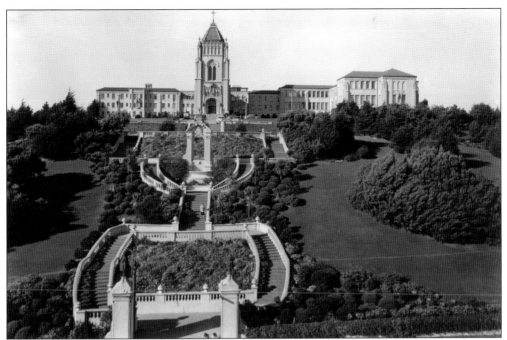

The San Francisco College for Women, later called Lone Mountain College, was founded in 1929 by the Religious of the Sacred Heart. Located on the former site of a cemetery, this lovely campus is now owned by the University of San Francisco, a Jesuit institution. (Courtesy of the Archives for the Archdiocese of San Francisco.)

The campus of the University of San Francisco looks particularly idyllic and the landscaping lush in this early photograph. The building in the background is Campion Hall, which houses classrooms and, for many years, Gill Theatre, used by the College Players. (Courtesy of St. Ignatius, the University of San Francisco, and the California Province of the Society of Jesus.)

For St. Ignatius students, football has always been a fiercely competitive sport. Many graduates have vivid memories of games played long ago. (Courtesy of St. Ignatius, the University of San Francisco, and the California Province of the Society of Jesus.)

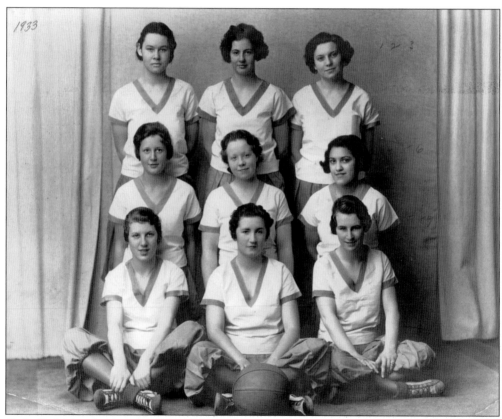

Catholic high schools, regardless of their size, have always provided activities for students to explore talents. This Star of the Sea Academy basketball team dates to 1933. Perhaps these students were also members of a drama club or on the staff of the school newspaper. (Courtesy of Star of the Sea School.)

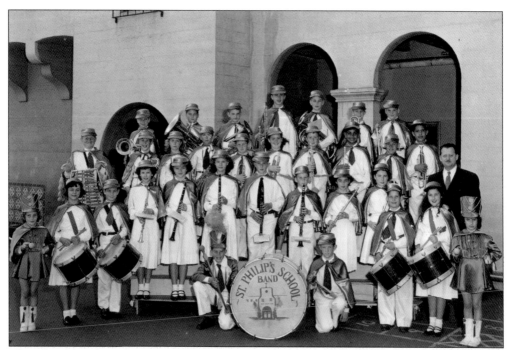

The school band is where many young people in the archdiocese honed their musical talent. The 1949 St. Philip Elementary School band practices for a performance. (Courtesy of the Archives for the Archdiocese of San Francisco.)

The St. Monica School Choir was photographed with Fr. Edgar Boyle. He is remembered in the parish for his constant encouragement of all parishioners to sing, including adults who may or may not have had musical ability. Father Boyle was later appointed music director for the archdiocese. (Courtesy of the Archives for the Archdiocese of San Francisco.)

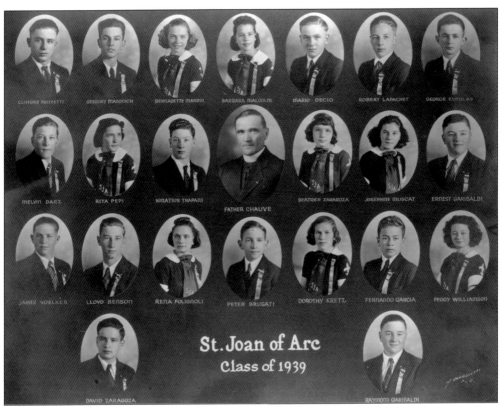

The 1939 graduating class of St. Joan of Arc School had two set of siblings in the same class, Beatrice and David Zaragoza and twins Raymond and Ernest Garibaldi. Beatrice became a Maryknoll nun serving in Nicaragua for decades. Her brother, David, died in the Battle of the Bulge. Both the Garibaldis joined the service. Raymond enlisted in the Coast Guard and Ernest in the navy. (Courtesy of the Garibaldi family.)

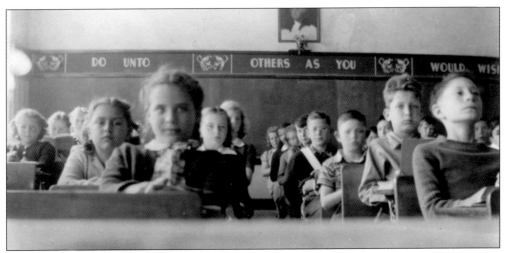

This Star of the Sea School classroom had many reminders for students to be good: a crucifix, the American flag, a picture of George Washington, and the motto above the blackboards. The school celebrates its centennial in 2009. (Courtesy of Star of the Sea School.)

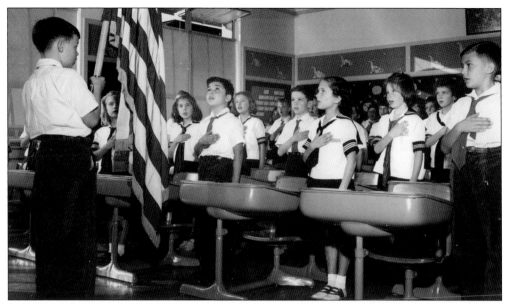

In 1948 at Most Holy Redeemer School, the day began with prayers and the Pledge of Allegiance. Dan Flynn is fifth from the right. Today many Catholic schools observe the same order, but often after the students assemble in the school yard. (Courtesy of Archives for the Archdiocese of San Francisco.)

Fr. William J. Clasby is seen here greeting aviation cadets. During World War II, he was a chaplain and retired as a colonel. In later years, the then Monsignor Clasby served as pastor of St. Vincent de Paul. (Courtesy of the Archives for the Archdiocese of San Francisco.)

Members of the Salesian Boys Club took part in a Columbus Day parade. Their route took them down Filbert Street from Telegraph Hill to Washington Square. (Courtesy of Theresa Avansino.)

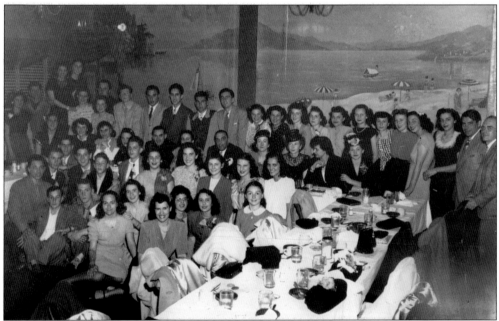

The Salesian Boys and Girls Clubs gathered for a dinner at a North Beach restaurant in this undated photograph. Angelo Fusco (seated center) was the director of the boys club. Bertha Bedoni (seated in the first row) was the director of the girls club. Bedoni taught physical education at Presentation High School and is still active in SS. Peter and Paul parish. (Courtesy of Theresa Avansino.)

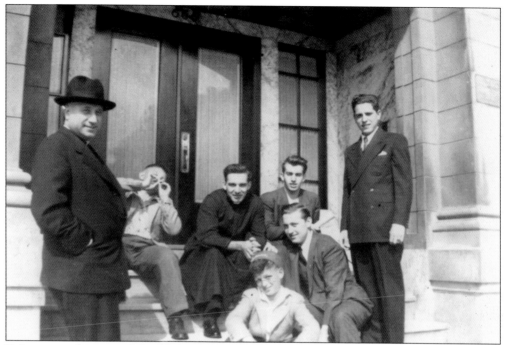

Relaxing on the steps of the SS. Peter and Paul Rectory on Filbert Street are Fr. David Zunino, S.D.B., (center); an unidentified priest (left); and members of the Salesian Boys Club. To the right of Father Zunino is Joe Bruno, below Joe is Ed Tardelli, and on the far right is Herb DeGrasia. The photograph dates to the 1940s. (Courtesy of Marie Schnell Harrington.)

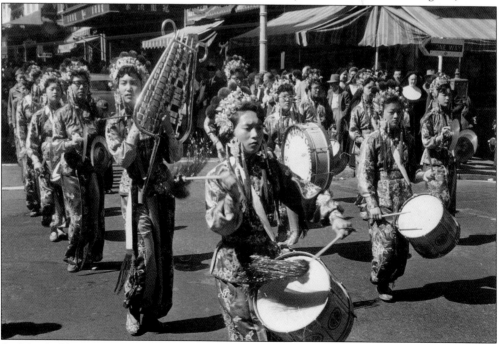

St. Mary's Chinese Girls Drum Corp is known throughout San Francisco. Here they march in a San Francisco parade. (Courtesy of the Sisters of St. Joseph of Orange.)

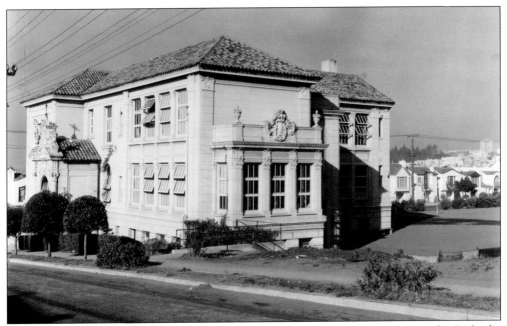

This is the original St. Cecilia School on Seventeenth Avenue and Vicente, in the Parkside. Additions have been made over the years. Past students recall the days when their quarterly report cards were handed to them by a parish priest with comments about areas for improvement. (Courtesy of the Archives for the Archdiocese of San Francisco.)

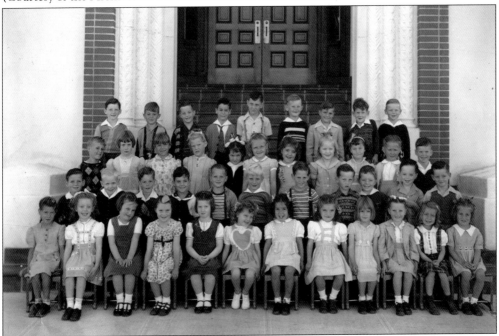

The 1945 first graders of Holy Name School sat still long enough for this class photograph. Karen Knutsen is fifth from the left in the first row, and next to her is her friend Beverly Stone, the girl with the heart-shaped bodice. The students did not have uniforms at this time. Their teacher was Sr. Mary Francesca, R.S.M.. (Courtesy of the Knutsen family.)

A group of Archdiocesan Mother's Guild leaders gathered for this photograph on June 2, 1950. Mother's Guilds or Mother's Clubs are known for their fund-raising and organizational work on behalf of their parishes and children's schools. (Courtesy of the Archives for the Archdiocese of San Francisco.)

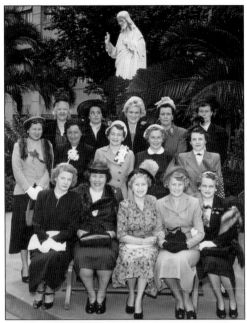

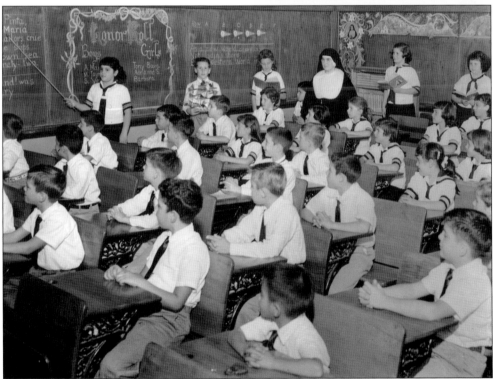

Students in a 1957 classroom at SS. Peter and Paul School had much to be proud about considering the "Honor Roll" on the blackboard. The school is located above the parish church on Filbert Street. Masses celebrated during school days are punctuated by distant bells for recess and lunch and the soft drum of hundreds of small feet. (Courtesy of Archives for the Archdiocese of San Francisco.)

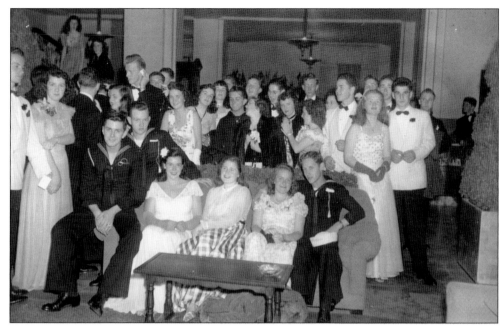

Students of the Star of the Sea Academy attended a formal gathering that included navy men. During World War II, there were frequent dances at the Apostleship of the Sea. (Courtesy of Star of the Sea School.)

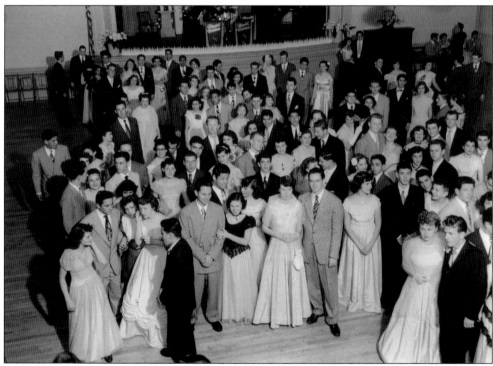

St. Peter High School, a Christian Brothers school in the Mission District, held their prom in the school auditorium in the late 1940s. Perhaps their dates were students from their sister school, St. Peter Academy. No other parish had two high schools. (Courtesy of De La Salle Institute.)

A father-daughter dinner dance at their high school is a special event that many girls remember. This dance at Presentation High School was held in 1956. (Courtesy of the Presentation Archives.)

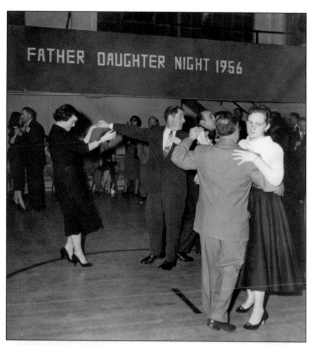

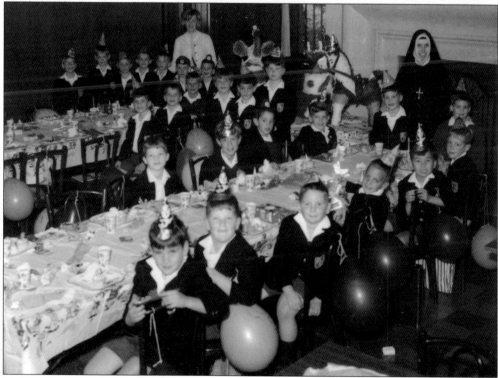

Second graders at Stuart Hall for Boys celebrated the birthday of their classmate Joseph C. M. Hall, in 1965 with Mrs. Frank B. Firpo and Sr. Helen Carroll, RSCJ. Sister Carroll was Stuart Hall's founding principal. One of the rules of her order, the Religious of the Sacred Heart, is to not correct every fault of a child. (Courtesy of Schools of the Sacred Heart Archives.)

Students at Notre Dame des Victoires High School students make their way to their next class in this photograph taken during the 1946–1947 school year. (Courtesy of the Sisters of St. Joseph of Orange.)

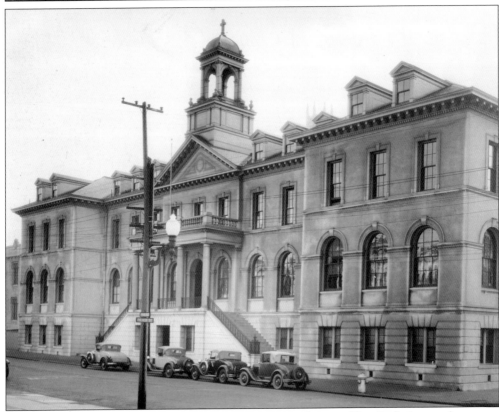

St. Rose Academy, established in 1854 by the Dominican Sisters of San Rafael, moved to a new home, designed by Albert Pissus, in early 1906. Second- and third-generation St. Rose students were called Rosebuds. Although the school closed after devastating damage by the 1989 Loma Prieta earthquake, large reunions are very well attended. One St. Rose alumna, Heather Fong, is the current chief of police of San Francisco. (Courtesy of the Archives for the Archdiocese of San Francisco.)

In many old parishes, there were separate schools for boys and girls. In Mission Dolores parish, girls received grammar school and high school educations from the Sisters of Notre Dame de Namur in this classic building across the street from Mission Dolores. The boys were educated at Mission Dolores School. (Courtesy of the Archives for the Archdiocese of San Francisco.)

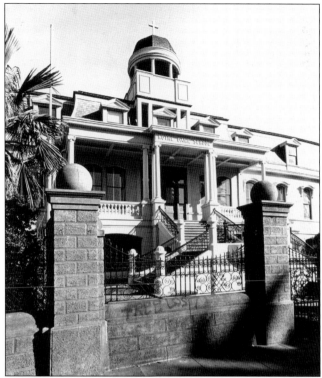

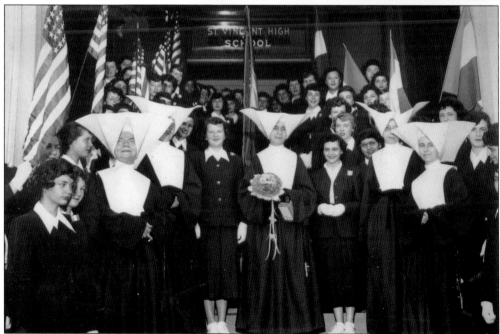

St. Vincent High School was founded by the Daughters of Charity of St. Vincent de Paul. Here the mother general of the order is greeted by Sisters and students during a visit. Its successor school, Cathedral High, merged with Sacred Heart High School to become Sacred Heart Cathedral Preparatory in 1987. (Courtesy of Sacred Heart Cathedral Preparatory.)

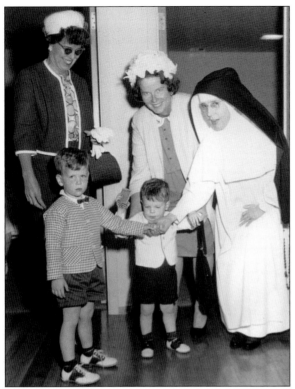

In the 1950s and 1960s, a popular event for Immaculate Conception Academy graduates was "Baby Day." It was their opportunity to introduce their offspring to their teachers. Here Sr. M. Ancilla, O.P., greets several smartly dressed young boys. (Courtesy of the Archives of the Dominican Sisters of Mission San Jose, Immaculate Conception Academy.)

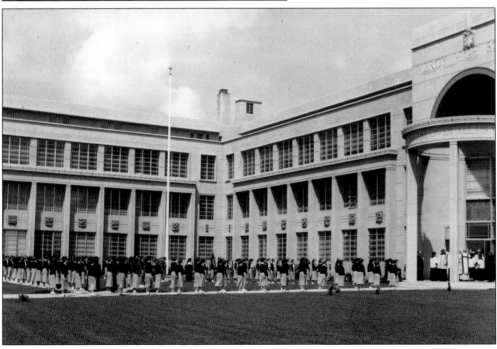

Mercy High School students file into the school in this photograph from the 1950s. There are over 8,000 Mercy graduates. Among them is Joann Hayes-White, San Francisco's fire chief. (Courtesy of Mercy High School.)

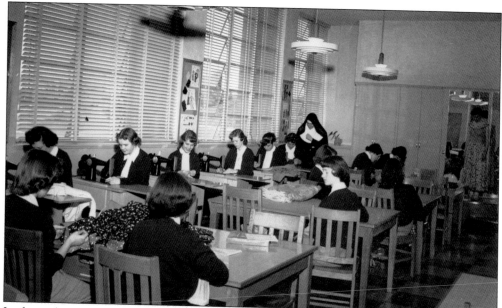

In the early years at Mercy High School, there was a "Catholic Life" portion of the curriculum. It included charm, home decor, and this sewing class taught by Sister Lillian. The goal was to equip young women with useful skills for their future lives as wives, mothers, and volunteers. It also helped them to increase their teenage wardrobes. That classroom is now a chemistry lab. (Courtesy of Mercy High School.)

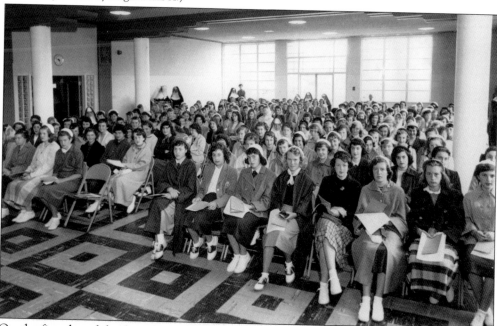

On the first day of the first class at Mercy High School, San Francisco, in 1952, the freshmen assembled in Rist Hall. Established by the Sisters of Mercy, the construction costs for the school came in at under $1 million. Students had the exciting task of forging new traditions, such as choosing their school colors (red and white) and a school song. (Courtesy of Mercy High School.)

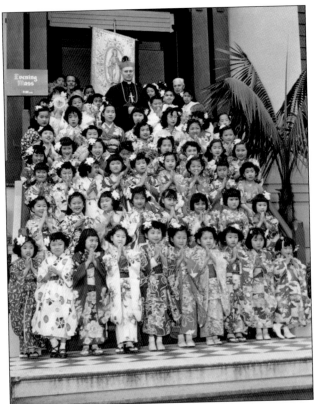

Students of Morning Star School, the parish school of St. Francis Xavier, assembled on the steps of the church on May 3, 1955. St. Francis Xavier was the Japanese National Church in San Francisco. The Divine Word priests who served the parish are a German missionary order. Many had experience as missionaries in Japan. (Courtesy of the Archives for the Archdiocese of San Francisco.)

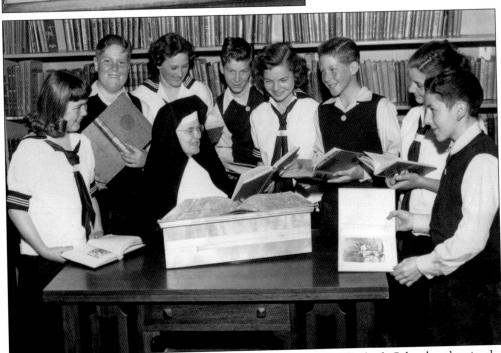

Sister Alexis Cronin, P.B.V.M., and some of the students of St. Elizabeth School gather in the school library in this photograph from 1956. (Courtesy of St. Elizabeth Church.)

Francois and Odette Le Pendu and their sons Jean-Louis (left) and Claude (right) visited Archbishop Riordan High School in 1960, Claude's freshman year. The family lived in St. Finn Bar's parish, where the boys served Mass. Francois was an engineer. Jean-Louis became a Hawaii Bar Pilot and Claude an airline pilot. Odette is a chevalier of the Legion of Honor (military), an honor given by the French government for her service in the Resistance. (Courtesy of the Le Pendu family.)

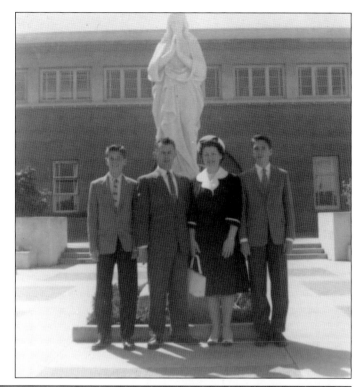

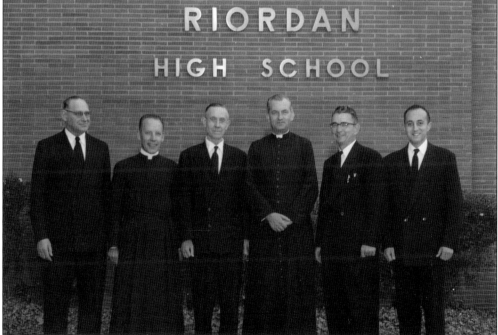

Archbishop Riordan High School was founded in 1949 by the Marianists as a college preparatory school for young men. Here the Brothers pose outside the school on August 24, 1958. Br. John Samaha, a frequent contributor to *Leaves* Catholic magazine, is seen at the far right of the photograph. (Courtesy of Archbishop Riordan High School.)

Kathy Symkowick, St. Thomas Apostle class of 1964, marked her graduation in a photograph with Fr. Joseph Malani, an associate pastor. Kathy's teachers at St. Thomas Apostle were the Sisters of St. Joseph of Carondelet. (Courtesy of Kathy Symkowick.)

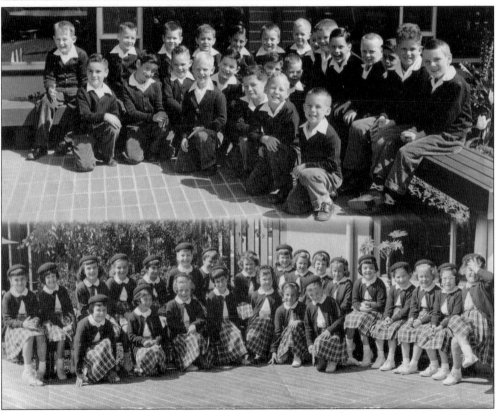

On April 15, 1959, the first-grade class of St. Thomas More School took a field trip to the Merced Branch of the San Francisco Public Library. (Courtesy of St. Thomas More School.)

Msgr. Harold "Happy Harry" Collins of St. Cecilia Church burned the mortgage of the debt-free and recently consecrated church in 1965, with the assistance of parishioner James Lang. This event was held at the Hilton Hotel with a group of 1,600, including Gov. Edmund G. "Pat" Brown. The background banner proclaims the parish motto: "The Finest, the Greatest and the Best." (Courtesy of the Archives for the Archdiocese of San Francisco.)

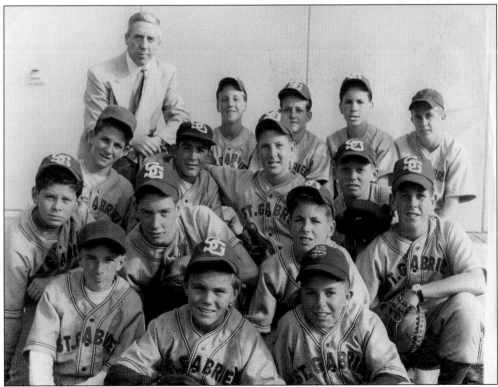

This St. Gabriel baseball team was coached by a school dad, John Brennan. Brennan performed this task from 1955 to 1960. (Courtesy of St. Gabriel School.)

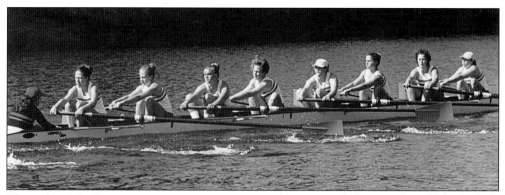

The girls of St. Ignatius participate in a variety of sports, including track, golf, basketball, volleyball, cross-country, soccer, swimming, and crew. (Courtesy of St. Ignatius, the University of San Francisco, and the California Province of the Society of Jesus.)

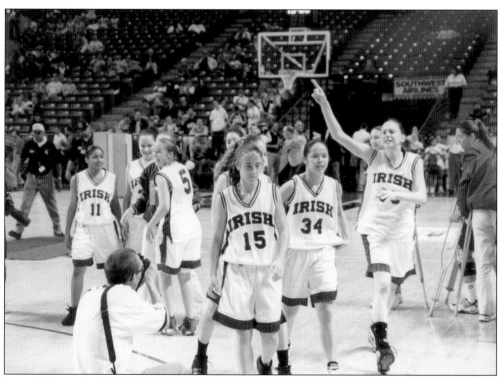

Sacred Heart Cathedral Preparatory girls have won many championships. This is the NorCal Division winning team of 1998. (Courtesy of the De La Salle Institute.)

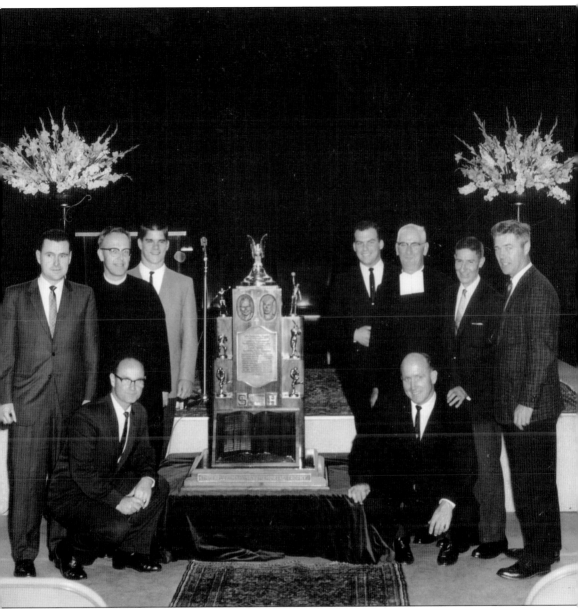

In 1964, Fr. Thomas Reed, S.J., of St. Ignatius (left) and Br. Edmund McKevitt of Sacred Heart (right) posed with students and teachers next to the Bruce-Mahoney Trophy. The trophy carries the names of Bill Bruce of St. Ignatius and Jerry Mahoney of Sacred Heart to represent the alumni from the two schools who fell in World War II. The schools have the longest running athletic competition west of the Rockies, dating from a rugby match held in 1893. The schools now compete for the Bruce-Mahoney Trophy in football, baseball, and basketball. The school that wins two out of three games takes the trophy home for the year. (Courtesy of the De La Salle Institute.)

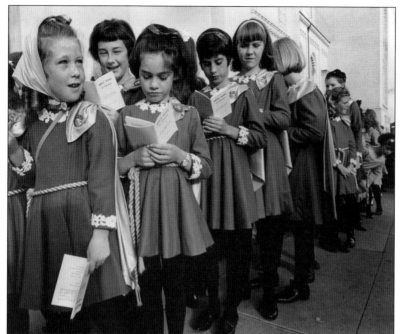

Young Irish dance students line up to enter St. Anne of the Sunset Church for Mass on October 24, 1967. (Courtesy of the Archives for the Archdiocese of San Francisco.)

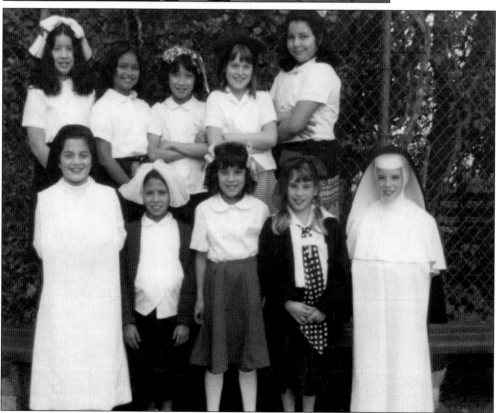

These students of St. James School appear delighted to dress in past uniforms and the old and new Dominican habits, although it probably wasn't Halloween. (Courtesy of St. James School.)

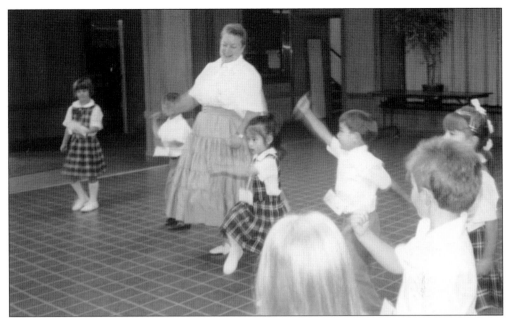

Geraldine ("Jerry") Washburn, folk dancing instructor at St. Brendan School, is shown with younger students. Washburn has taught Virginia reels, line dancing, and the chicken dance to generations of students. She has been on the staff at St. Brendan since 1955. (Courtesy of St. Brendan School.)

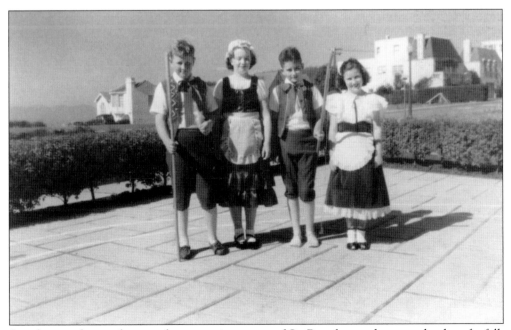

Standing in the sunshine at the corner is a group of St. Brendan students on the day of a folk dancing exposition. These annual events showcased students' coordination and their mother's costume-making abilities. (Courtesy of St. Brendan School.)

Sister and the girls limber up for exercise in the school yard of Immaculate Conception Elementary School on Folsom Street Hill around 1990. (Courtesy of St. Anthony/Immaculate Conception School.)

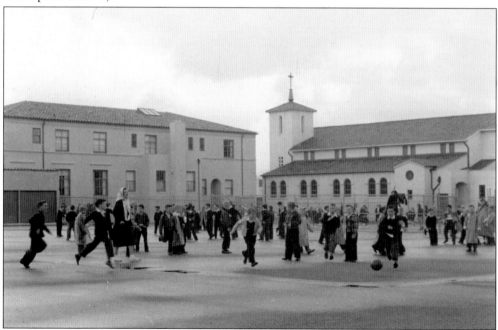

For decades, St. Gabriel School had the largest enrollment of any Catholic elementary school in the West and a large school yard as well. At one time, the school had four classes per grade. The school enjoys the loyalty of past students, including several who teach there. Jackie de Leon has taught at St. Gabriel since 1958. (Courtesy of St. Gabriel School.)

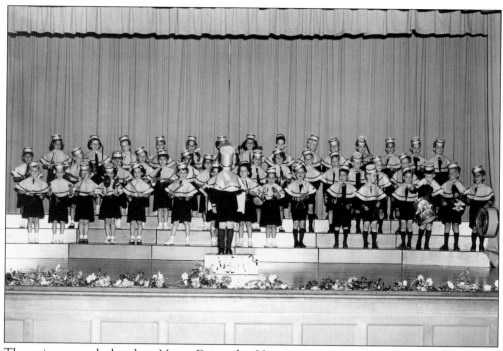

The primary-grade band at Notre Dame des Victoires gives a performance in fashionable costumes. (Courtesy of the Sisters of St. Joseph of Orange.)

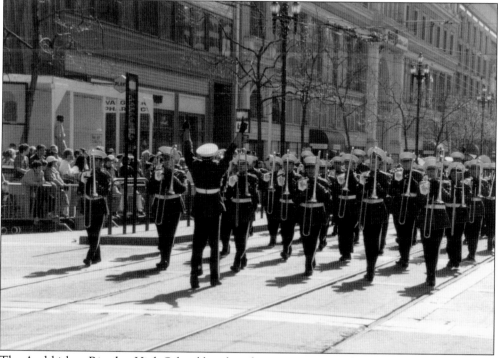

The Archbishop Riordan High School band performs at many parades in the San Francisco Bay Area. Here they perform at a Veterans Day parade on Market Street. (Courtesy of Archbishop Riordan High School.)

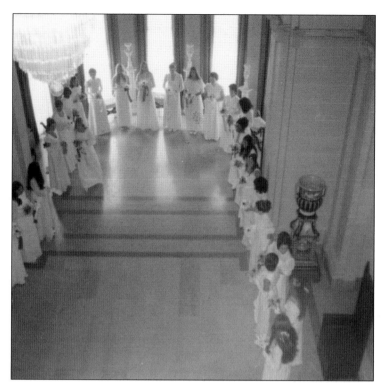

The Senior Tea is a tradition at the Convent of the Sacred Heart. The class of 1971 does some last-minute scurrying to get ready to receive their guests: mothers, grandmothers, aunts, cousins, and assorted well-wishers. After moving through the receiving line, the guests enjoyed small, crust-less sandwiches, petit fours, and tea in Our Lady's Parlor. (Courtesy of private collection.)

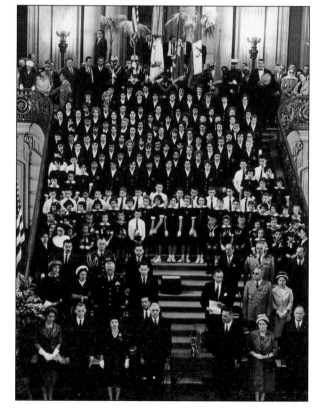

Students at Notre Dame des Victoires performed for French president Charles de Gaulle at San Francisco's city hall. Notre Dame des Victoires was established in 1924 and continues to teach French language and culture. (Courtesy of the Sisters of St. Joseph of Orange.)

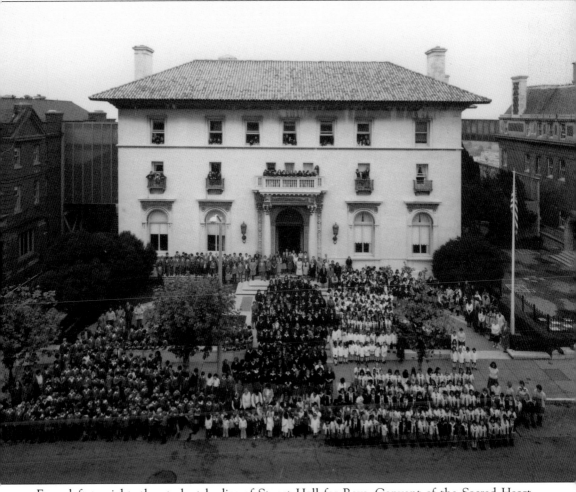

From left to right, the student bodies of Stuart Hall for Boys, Convent of the Sacred Heart (Senior School), and Convent of the Sacred Heart (Junior School) gathered for this photograph in 1970. Convent of the Sacred Heart was founded in San Francisco in 1887 by the Religious of the Sacred Heart. Stuart Hall was founded in 1956. Known as the Schools of the Sacred Heart, Convent and Stuart Hall belong to a worldwide network of schools. Students have held many fund-raisers for a new girls' school in Uganda. U.S. senator Dianne Feinstein is a graduate of Convent. Convent has had several locations, including Franklin and Ellis Streets and Jackson and Scott Streets. (Courtesy of Schools of the Sacred Heart Archives.)

The Convent for Star of the Sea School featured a roof garden. Perhaps this was a frequent retreat for the Sisters of St. Joseph of Carondolet after a day in the classroom. (Courtesy of Star of the Sea School.)

The Mission Dolores custodian, Jerry Cannon, ponders work ahead. (Courtesy of the Archives for the Archdiocese of San Francisco.)

Patricia Pinnick (second from left) has the distinction of being the longest serving teacher in San Francisco parochial schools. After 50 years of service at St. Cecilia School, she now teaches part-time at St. Thomas More School. Kathy Kays (left) and Marian Connelly (right) are former students of Pinnick and current faculty. Sr. Marilyn Miller, principal, (third from left) is a St. Cecilia graduate. (Courtesy of Patricia Pinnick.)

From left to right, the staff of St. Thomas Apostle School paused for this recent photograph: (first row) Nelson Lam, director of the Chinese Language School, and Judy Borelli, principal; (second row) Fr. Daniel Maguire, pastor; Carol Harrison Wong, vice principal; and Barbara Anderson, dean of students. (Courtesy of Fr. Daniel Maguire.)

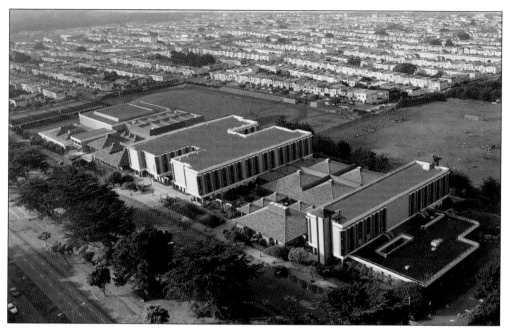

St. Ignatius College Preparatory at Thirty-ninth Avenue and Rivera has expanded in recent years. One of the most-enjoyed features, an indoor pool, was only a dream for graduates of prior St. Ignatius campuses. At the Stanyan Street location, upperclassmen attempted to dupe freshmen with tickets to the third-floor swimming pool. Not counting the basement, the school only had two floors. (Courtesy of St. Ignatius, the University of San Francisco, and the California Province of the Society of Jesus.)

Charles W. ("Chuck") Dullea, a St. Ignatius graduate (1965), was appointed principal in 1998, the first layperson to hold that post. Many graduates have served as teachers and administrators at the school. It has been coeducational since 1989. (Courtesy of St. Ignatius, the University of San Francisco, and the California Province of the Society of Jesus.)

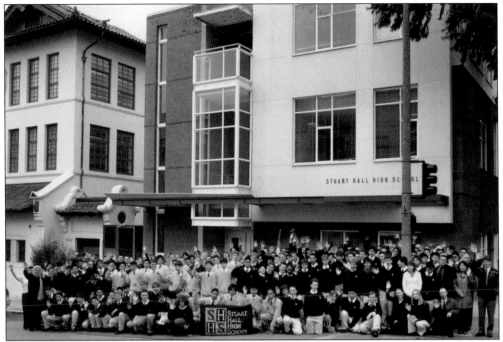

Stuart Hall High School, part of the network of Schools of the Sacred Heart of the Religious of the Sacred Heart, was established in 2000. The first new Catholic high school in the city since 1952, Stuart Hall High is located at the site of the former Morning Star School of St. Francis Xavier on Octavia at Pine Street. The student body, teachers, and staff took a break for this picture in 2004. (Courtesy of the Schools of the Sacred Heart Archives.)

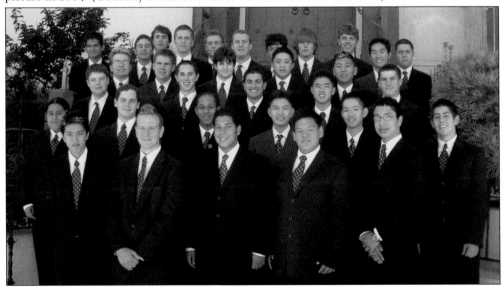

The class of 2004, Stuart Hall High School's first graduates, posed on the steps of St. Benedict Church (formerly St. Francis Xavier). The long list of prestigious universities the graduates attend attests to the high academic expectations of the teachers, students, and parents. The school also places a great emphasis on social service. (Courtesy of the Schools of the Sacred Heart Archives.)

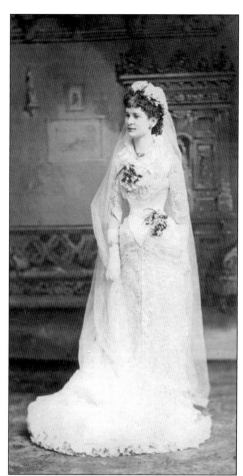

Alice Phelan married Francis John Sullivan at St. Ignatius Church on May 11, 1882. She had been educated at Notre Dame de Namur in San Jose, and her husband had attended school in England. Alice was the first president of Little Children's Aid, a group founded in her parlor. (Courtesy of Sheila O'Day Kiernan.)

James Duval Phelan posed at age five in 1866. Phelan joined the family banking firm, became a civic leader, and was San Francisco mayor (1897–1902) and a U.S. senator (1915–1921). He donated $100,000 to his alma mater, St. Ignatius, for the construction of the Stanyan Street campus (1929–1969). (Courtesy of Sheila O'Day Kiernan.)

Three

CHARITY

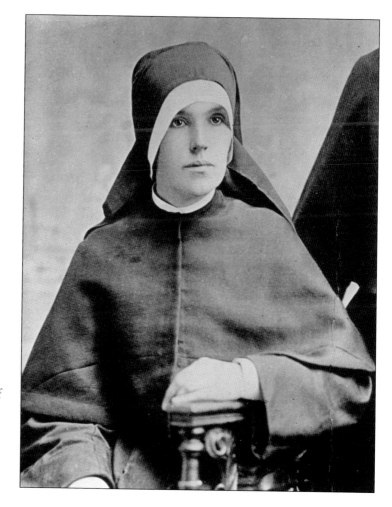

Elizabeth "Lizzie" Armer had a mission to minister to the poor of the city. She helped to found the Sisters of the Holy Family and became known as Mother Dolores. The Sisters began a day home to care for the children of working parents. The day homes continue to this day. (Courtesy of the Archives for the Archdiocese of San Francisco.)

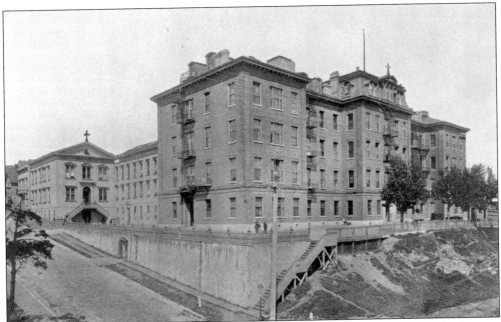

In 1854, Sr. Mary Baptist Russell of the Sisters of Mercy came to San Francisco to help the poor of the city. The Sisters purchased the State Marine and County Hospital and renamed it St. Mary's Hospital. In 1905, the Sisters purchased the block bounded by Hayes, Stanyan, Shrader, and Grove Streets and made plans to build a new hospital. (Courtesy of a private collection.)

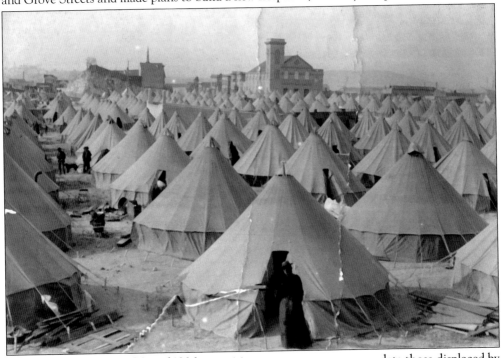

After the earthquake and fire of 1906, tent cities were set up to accommodate those displaced by the disaster. This tent city was in the vicinity of Nineteenth and Tennessee Streets. St. Teresa Church is visible in the background. (Courtesy of St. Teresa parish.)

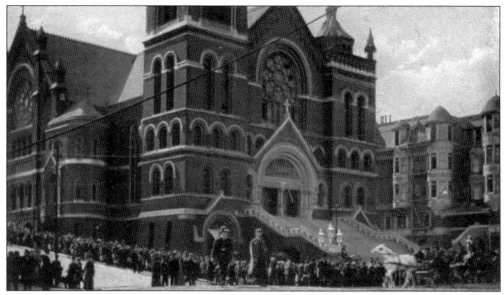

In the weeks and months following the 1906 earthquake and fire, bread lines were set up on the edges of the affected areas for the hungry and homeless. This bread line, at St. Mary's Cathedral on Van Ness Avenue, was possibly the grandest, but considering the church's involvement in community life, it was a natural gathering place. (Courtesy of the Archives for the Archdiocese of San Francisco.)

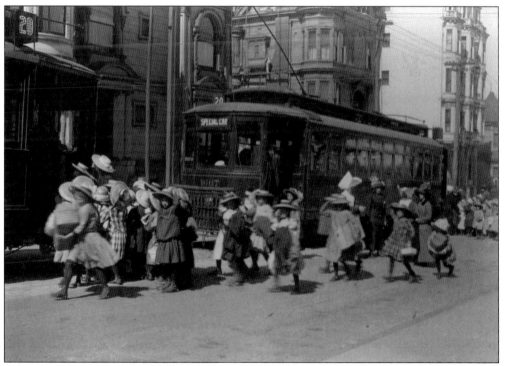

After the Roman Catholic Orphanage at 700 Newhall Street was destroyed in 1912, children were evacuated to St. Vincent High School on Ellis Street. (Courtesy of the Archives for the Archdiocese of San Francisco.)

Bertha Welch was an early benefactor of religious orders, particularly the Jesuits. She gave generously to St. Ignatius College, later the University of San Francisco. The one-time residence of the St. Ignatius High School faculty, next to St. Ignatius Church on Fulton Street, was named Welch Hall. (Courtesy of St. Ignatius, the University of San Francisco, and the California Province of the Society of Jesus.)

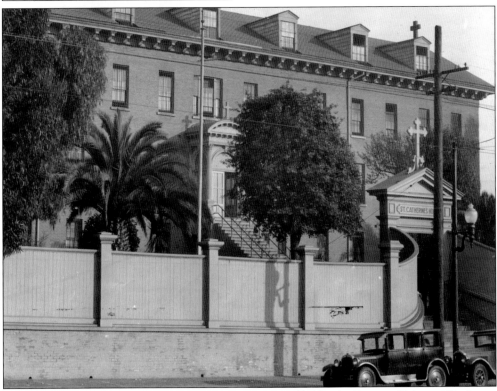

The St. Catherine's Home at 901 Potrero Avenue was staffed by the Sisters of Mercy. The home was a combination of shelter and retraining center for women who had come from difficult circumstances. (Courtesy of the Archives for the Archdiocese of San Francisco.)

711 ..Whist Party..

Will be Given for the

Benefit of All Hallows' Church

Tuesday Evening, June 10, 1919

AT OPERA HOUSE, 14TH AND RAILROAD AVES.

First Prize—$10.00—Merchandise Order—$10.00

48

TICKETS, 25 CENTS

All Hallows' Church had whist parties and, probably in later years, bingo. Card games were a popular form of parish entertainment and fund-raising in the years before radio and television. (Courtesy of Bernadette Hooper.)

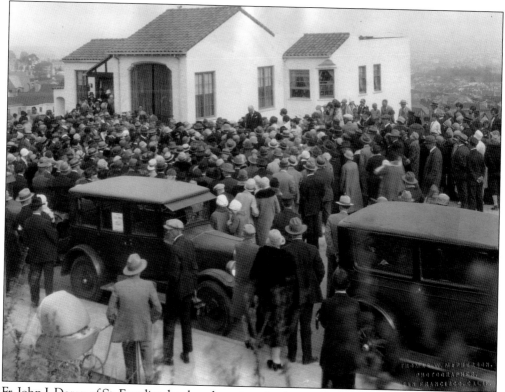

Fr. John J. Doran of St. Emydius developed a unique fund-raiser for their new church building. Casa Emydio, a Spanish-style home, was built at 245 Brentwood Street. The house was raffled off at a ball held in the Civic Auditorium on December 15, 1927. The winner, Wilhemina Plamondon, had already contributed generously to the church project. (Courtesy of St. Emydius Church.)

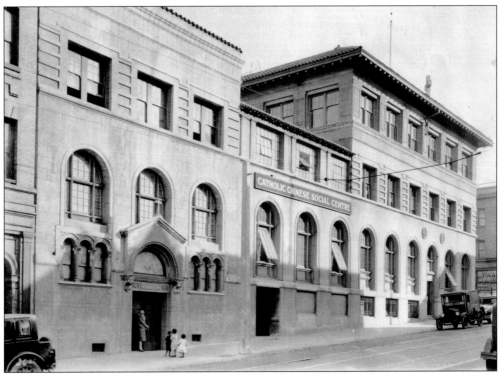

The Chinese Catholic Mission at Stockton and Clay Streets is familiar to generations of San Franciscans. Its construction was made possible by a generous gift from Bertha Welch. (Courtesy of the Archives for the Archdiocese of San Francisco.)

OLD FASHION

BARN DANCE

Given by

Salesian Council No. 565, Y. M. I.

and

Auxilian Institute No. 63, Y. L. I.

WEDNESDAY EVENING, MAY 26, 1920

In Young Men's Institute Auditorium, 50 Oak Street

ADMISSION 30 CENTS **UNION JAZZ MUSIC**

Wednesday evening, May 26, 1920, was a night for kicking up heels at the YMI (Young Men's Institute) building. An old-fashioned barn dance for the price of 30¢ a ticket featured a union jazz band. Many city residents of that era were union members. (Courtesy of Bernadette Hooper.)

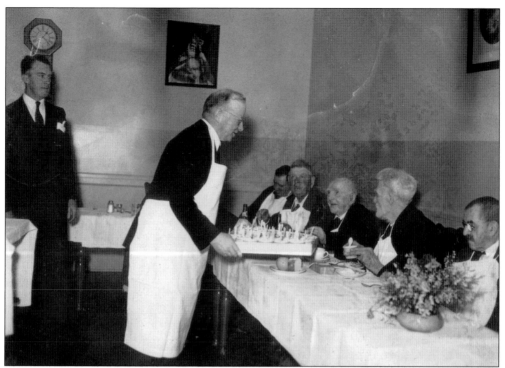

The St. Anthony Dining Room at St. Boniface Church celebrated St. Joseph's Day in 1936 by distributing ice cream cups to visitors to the dining room. (Courtesy of the Archives for the Archdiocese of San Francisco.)

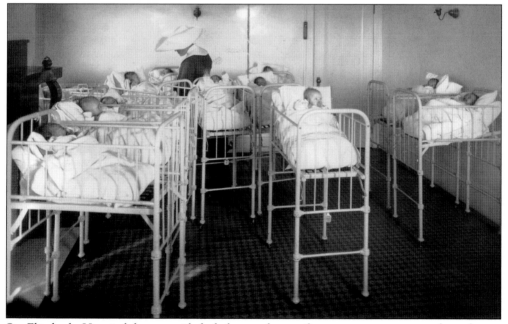

St. Elizabeth Hospital has provided shelter and care for pregnant women and newborns. This nursery photograph dates to 1927. (Courtesy of the Archives for the Archdiocese of San Francisco.)

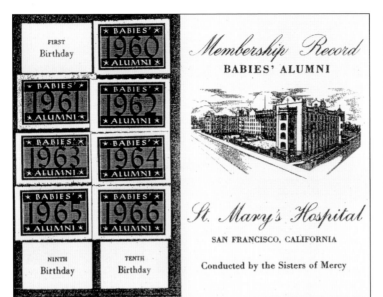

The Auxiliary of St. Mary's Hospital began the Babies Alumni Program in 1954 for parents and their children born at the hospital. Birthday cards were sent to participating members of the Babies Alumni. Their donations were used to purchase equipment for the obstetrical department. (Courtesy of the Garibaldi family.)

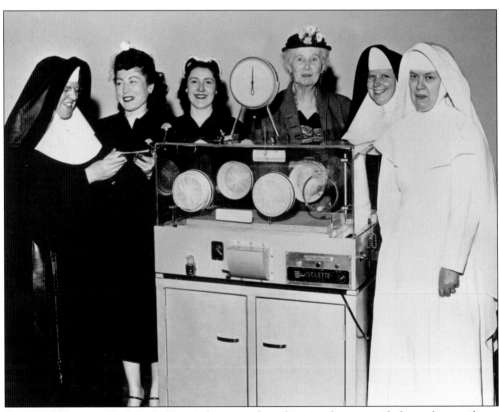

Sisters of Mercy at St. Mary's Hospital accept their first incubator, a gift from the auxiliary. From left to right are Sr. Mary Phillipa, three auxiliary members, Sr. Mary Anita, and Sr. Mary Raymond. (Courtesy of St. Mary's Medical Center and the Sisters of Mercy, Burlingame Regional Community.)

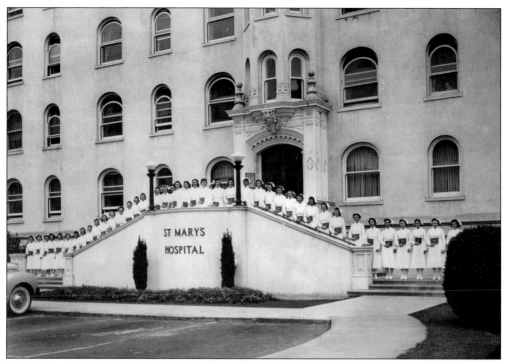

The nursing students at St. Mary's College of Nursing are posed on the stairs of the hospital in this undated photograph. (Courtesy of the Archives for the Archdiocese of San Francisco.)

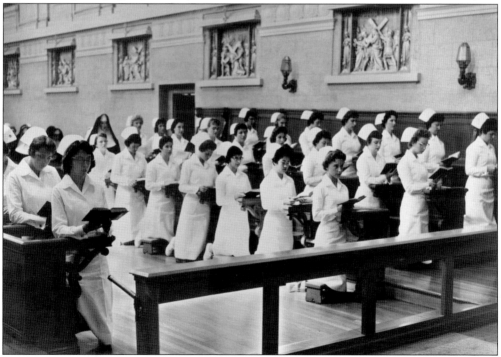

St. Mary's College of Nursing students pray in their chapel on their graduation day. (Courtesy of St. Mary's Medical Center and the Sisters of Mercy, Burlingame Regional Community.)

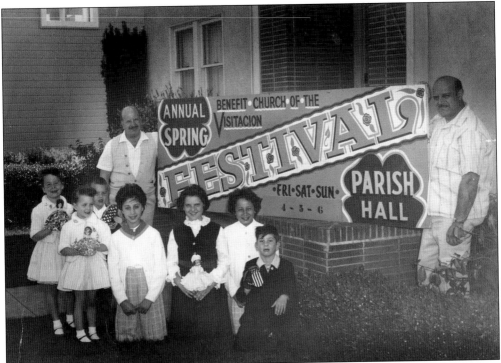

The children of the parish of the Church of the Visitacion hold items made by the Mother's Club to be sold at the annual Spring Festival to benefit the parish. The Mother's Club, formed in 1945, is the oldest parish organization. Joe De Felice (left) stands with an unidentified man. The photograph dates to the 1960s. (Courtesy of Edie Epps.)

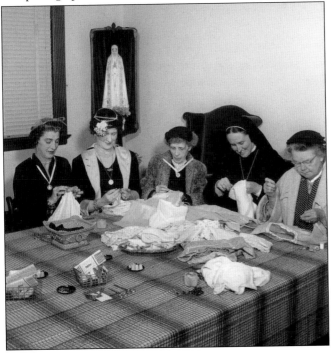

Preparing layettes for babies was a volunteer occupation. This group gathered with a Sister of the Helpers of the Holy Souls. Another group performed this service for decades for parishioners of St. Boniface. (Courtesy of the Schools of the Sacred Heart Archives.)

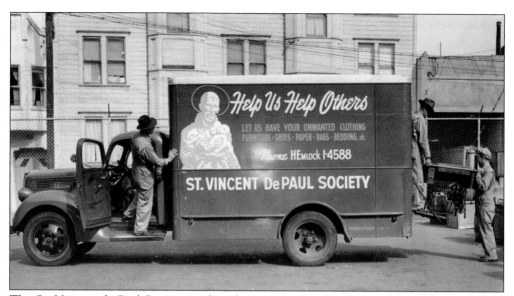

The St. Vincent de Paul Society truck makes its rounds collecting used items for resale at its stores. The society helps support programs for the elderly, detoxification facilities, families in crisis, and the homeless. (Courtesy of the Archives for the Archdiocese of San Francisco.)

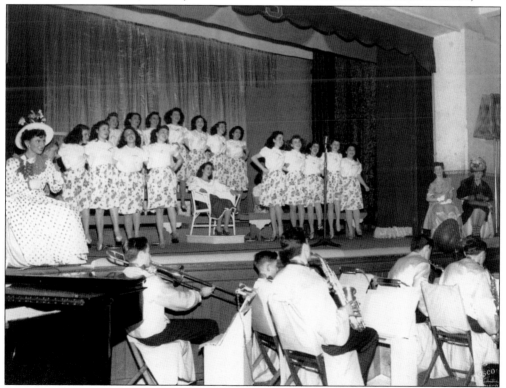

A variety show was presented by the Salesian Boys and Girls Clubs in the auditorium below SS. Peter and Paul Church in the 1940s. In that era, youngsters spent much of their time at church activities or the movies. The parish still hosts popular talent shows as fund-raisers. (Courtesy of Theresa Avansino.)

Cakes for sale, possibly made from scratch, are a feature of many parish fund-raisers. These ladies staffed the cake booth at the St. Anthony of Padua parish festival in October 1957. (Courtesy of St. Anthony/Immaculate Conception.)

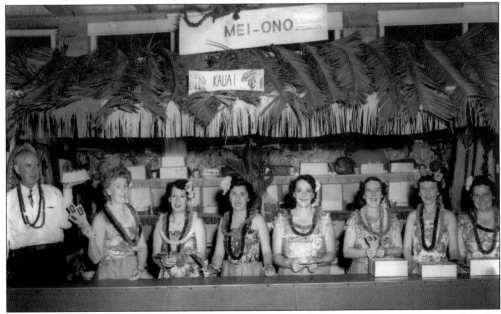

The parishioners of St. Gabriel have enjoyed many parish festivals. The 1950 festival had a Hawaiian theme. This booth was called the Fish Pond. (Courtesy of St. Gabriel School.)

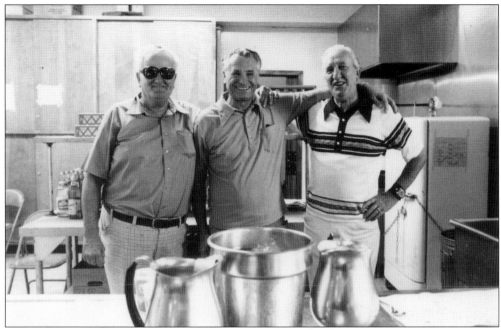

Franciscan Club members, active supporters of St. Anthony of Padua parish, could be counted on to plan, donate, and staff festivals and other fund-raisers. Posing in the kitchen at the 1974 parish festival are, from left to right, unidentified, Ray Calegari, and Mike Mihalek. (Courtesy of St. Anthony/Immaculate Conception School.)

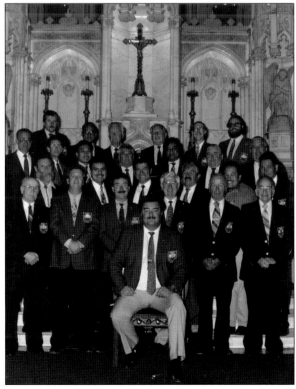

The Men of St. Paul, a charitable organization, was founded in 1951 to serve the needs of St. Paul's parish and school. This group has served as coaches, cooks, ushers, and construction crews. They sponsor monthly pancake breakfasts, an annual St. Patrick's Day Dinner Dance, and the Aztec Barbecue. Current president Jim Woods is pictured in the first row, second from the left. (Courtesy of the Michael James Carey family.)

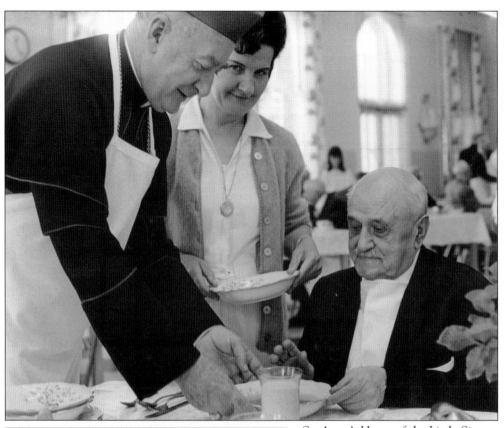

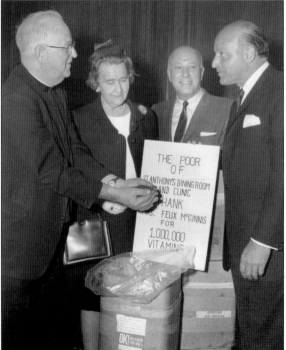

St. Anne's Home of the Little Sisters of the Poor was established in San Francisco in 1900 to care for the elderly poor. Archbishop Joseph T. McGucken was photographed with resident Joseph Kwartz and Delia Gili on May 1, 1966. For decades, on St. Joseph's Day, it was a tradition for church and civic leaders to wait tables at the home. (Courtesy of the Archives for the Archdiocese of San Francisco.)

The St. Anthony Dining Room and Clinic at St. Boniface parish was opened to help feed those in need. It now provides many other temporal services. This group, including Fr. Alfred Boeddeker, O.F.M., (left) and Mayor Joseph Alioto, (right) mark a donations goal. (Courtesy of the Archives for the Archdiocese of San Francisco.)

Students of Notre Dame des Victoires School donate to the Holy Childhood Collection of the "Pope's Poor Children Campaign" in 1955. (Courtesy of the Archives for the Archdiocese of San Francisco.)

Members of the St. John the Evangelist Women's Guild displayed their handiwork for sale at their Christmas Boutique in 1985. (Courtesy of St. John the Evangelist Church.)

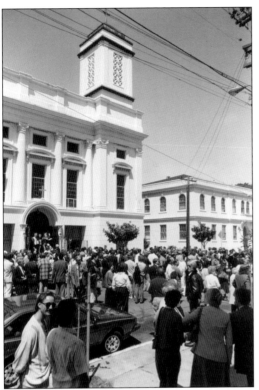

On August 3, 1986, Most Holy Redeemer parishioners, neighbors, local leaders, and friends mingled after the ceremony marking the beginning of the renovation of the former convent. Its new purpose was to house the Coming Home Hospice for AIDS patients. This is one of the many outreach programs that have distinguished this parish. (Courtesy of Most Holy Redeemer Church.)

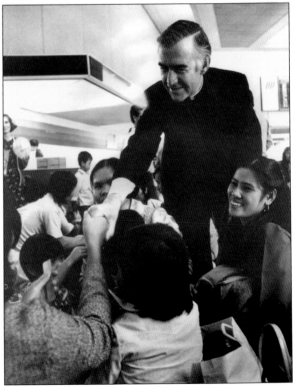

Archbishop John R. Quinn greeted Vietnamese refugees at the San Francisco International Airport in 1976. (Courtesy of the Archives for the Archdiocese of San Francisco.)